step by step art school

acrylics

step by step art school
acrylics

Wendy Clouse

hamlyn

First published in Great Britain in 1988 by Hamlyn,
a division of Octopus Publishing Group Ltd
2–4 Heron Quays, London E14 4JP

First published in paperback in 2002

This edition first published in 2005

10 9 8 7 6 5 4 3 2

Distributed in the United States and Canada
by Sterling Publishing Co., Inc.
387 Park Avenue South, New York, NY 10016-8810

ISBN-13: 978-0-600-61407-4
ISBN-10: 0-600-61407-7

A CIP catalogue record for this book is available from the British Library.

Designed and edited by Sports Editions Ltd
3 Greenlea Park, Prince George's Road
London SW19 2JD

Produced by Toppan Printing Co. Ltd

Printed and bound in China

Contents

Chapter 1
Introduction

Acrylic, one could say, is the most versatile of all painting mediums and this book demonstrates just that to both the beginner painter and to the more advanced artist. For the beginner acrylic paint can radically simplify the many exasperating technical problems that other painting mediums present, and to the more competent artist it opens new fields. Not only will it adapt itself to the techniques of oil and watercolours but it goes further, stretching these traditional techniques and offering exciting opportunities for flexibility in the artist's work. Frequently, established painters will not give acrylic a fair run, only too often bestowing on it their preconceived ideas about watercolour or oil paint, and give up before they have had time to explore its great potential. The beginner, on the other hand, who is not hampered by traditional techniques or prejudices will benefit most from this comparatively new paint which, in truth, is probably the easiest to use.

Acrylic, it seems, has gained an unfair reputation as having an advantage only when used in flat areas of bright colour. This, of course, is absurd and this point needs to be emphasized. The truth is that this paint is no brighter or harsher than any other. By trying for yourself, with the help of this book, it is hoped that you will gain a thorough understanding of the medium.

Introduction

WHAT ARE ACRYLICS?

Acrylic paint manufacturers use exactly the same pigments (colours) that makers of other painting mediums use. These are usually mineral, derived from the earth, or chemical products.

Paints only differ in their binder (the substance or adhesive which holds the dry ground pigment together). In watercolour the binder is gum arabic, which is solvent in water, with oil paint it is linseed oil, the solvent being turpentine or a petroleum substance, and with acrylic the binder is man-made plastic. The pigment is suspended in a milky-white liquid plastic which, on drying, turns perfectly clear. This is why acrylic paint tends to dry darker. The solvent for acrylic is water. While the paint is still wet or even damp it can be removed or dissolved with water, but when it is dry it is probably the hardest of all painting mediums to move.

WHY CHOOSE ACRYLIC?

People decide to use acrylic for any number of reasons. Perhaps they normally use oil or watercolour and want a change, or perhaps they have never painted before and wish to have the freedom of choice that acrylic offers. Being such a versatile medium it can be used in most of the techniques of any other type of paint.

Many people are bothered by the strong smell of oil, paint and turpentine

and so choose to use acrylic as it has very little odour. When using the traditional oil technique of building up a painting but employing acrylic, you will find the underpainting will dry very quickly and so allow the process to advance. Therefore consecutive layers of paint can be added quite rapidly. In the final stages of the picture glazes can be added within minutes Likewise final highlight opaques may be added almost instantly.

Mistakes can easily be corrected by painting over with white paint or acrylic gesso and then repainting. Minor mistakes can be easily corrected by just painting over the area as soon as it has dried. This is a fine medium for amateurs attending painting classes as transportation of the picture is so much easier. By the time the student has cleaned her brushes and put away the tubes of paint etc., the painting will be dry and can be popped into a bag or carried on to the bus without sticky problems. Storage is also much easier for the same reasons.

When using acrylic in watercolour techniques the painter will find laying one wash over another a simple task as the subsequent wash, of course being allowed to dry first, will not move or pick up at all, consequently producing very fresh watercolour-like paintings.

Acrylic used in any technique is permanent and will retain its colour indefinitely; it will not yellow with age as oil paint does (the effect of the linseed-oil binder) or fade as with watercolour. It can be painted on to any non-oily surface and is often used to paint large murals. Due to its flexibility paintings executed in acrylic paint on canvas, paper or any pliable material can be quite easily rolled up, without worry of the painted surface cracking.

Acrylic paints are manufactured at the Talens factory in Holland.

HISTORY OF ACRYLICS

Developed in the United States in the 1920s, acrylic paint was a product intended only for industrial use and until the late 1950s and early 1960s was generally only utilized in this field. The first artists to employ acrylic were probably of the American art movement called 'Pop Art', and this is most likely where it gained its reputation as a bright-coloured medium. It suited the imagery of these artists; they were painting a plastic world of billboards, soup cans, hamburgers, and bus stops, and a modern plastic medium such as acrylic must have appealed to them. At the same time American Abstract painters were experimenting with the medium – they were probably impressed by the rate at which acrylic paint dried as their art was instant and vital. Waiting for oils to dry must have been frustrating.

Acrylic was introduced into Europe in the 1960s, where artists such as David Hockney contributed greatly to the growing popularity of acrylic in the world of representational art. Hockney was renewing his interest in literal representation and his choice of paint was changing from oils to acrylics. During the 1960s and 1970s he painted many of his now well-known large portraits, mainly of his friends in their

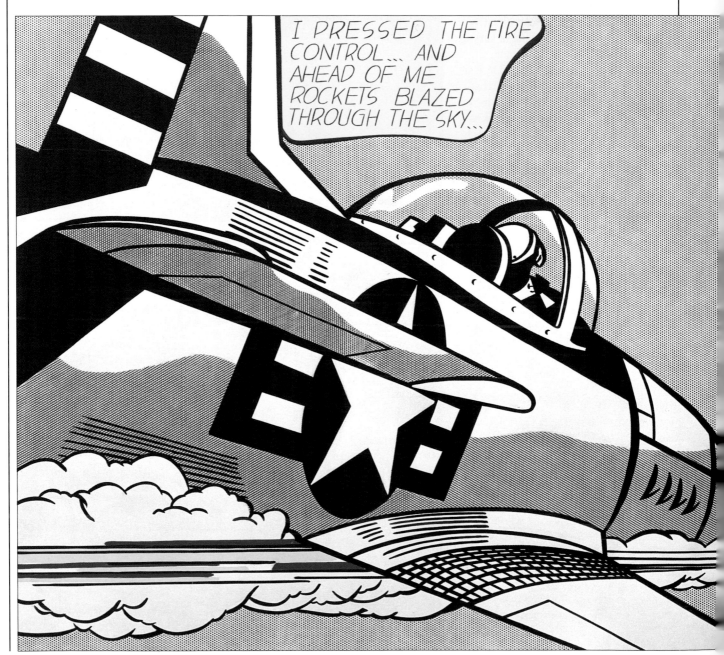

normal everyday environment, and used the newer medium, exploiting it to its limits.

Another artist of this era using acrylics was Roy Lichtenstein, an American 'Pop' artist. In 1960 he began to base his work on comic strips. Portrayed on these two pages is a reproduction of his painting "Wham". He imitated the dots of the printing press by laying a metal screen which had regularly spaced holes on to the canvas and brushed paint on to this with a toothbrush. With its quick drying quality acrylic was the perfect medium for this style of painting.

"Wham". Roy Lichstenstein 1963. Acrylic on canvas. 68 in × 106 in 172 cm × 269 cm).

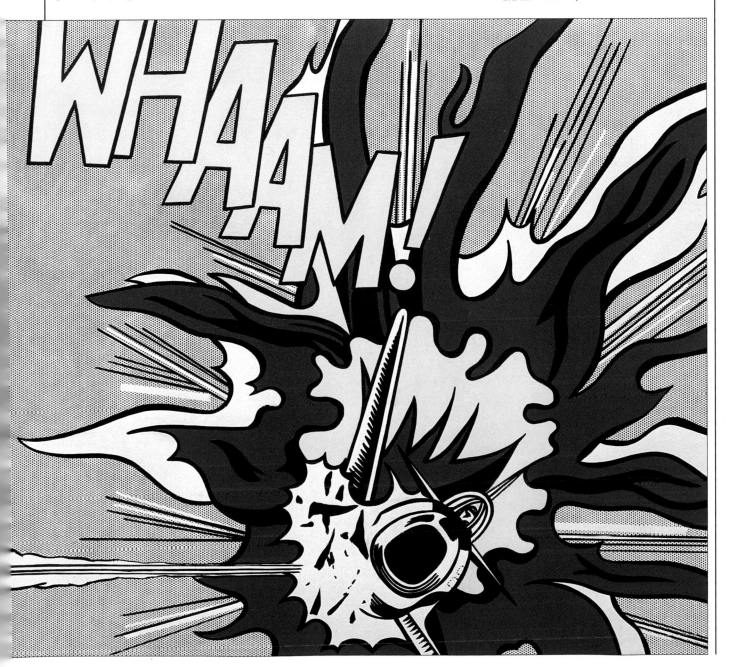

HISTORY OF ACRYLICS

1 *Dedicated to Florence,* by Terry Duffy illustrates the textures that can be obtained with Acrylics.

2 *The First Marriage,* by David Hockney – the English artist whose name has become synonomous with Acrylic Painting.

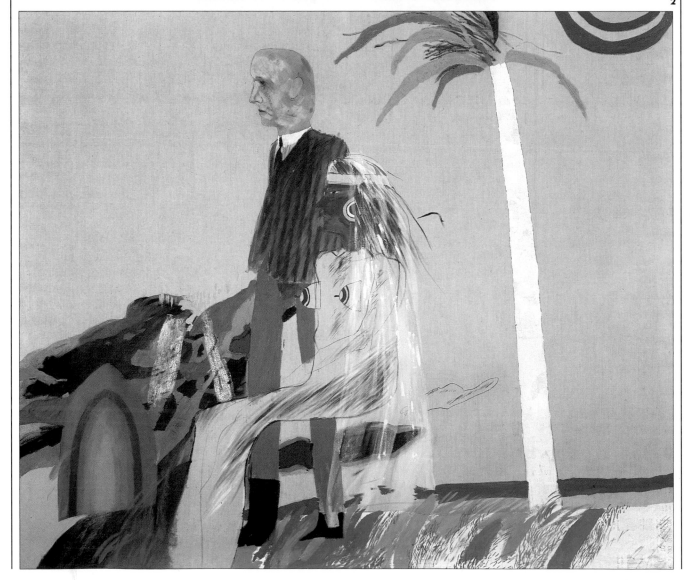

3 *The First Horn,* by Martin Nash is a forceful composition of Acrylic and mixed media on paper.

4 The soft subtle qualities that can be achieved with Acrylics are amply demonstrated by Stewart Lees in his landscape study, *Near Lathones.*

5 Bold, bright and richly coloured; *Glass Comport* by Tina Lambert.

6 A different technique again helps to demonstrate the full range of Acrylics; *Petals* by Joanne Wills.

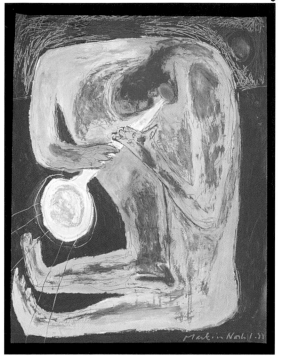

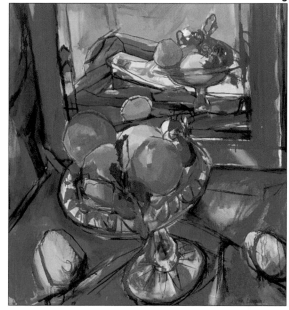

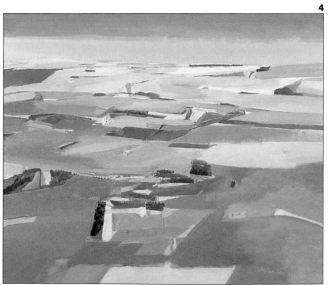

Chapter 2
Equipment

Painting with acrylics tends to be a mystery to many people; they seem to think of it as a new and unknown invention, requiring all sorts of special equipment. This is not so. In fact, with a relatively small amount of materials one can set out to paint a picture using any technique or method of painting.

It is advisable to buy a limited amount of materials to start with, but do buy the best that you can afford. Cheap paints, supports and brushes will only frustrate the budding artist and your interest in painting will soon wane. Art shops can be fascinating but they can also be overwhelming – full of all sorts of weird and wonderful equipment for the artist at exorbitant prices. So beware. Make a list out before you go shopping for the basic essentials and stick to it. With experience you will discover exactly what you need to add to your initial collection of materials.

To begin with half a dozen or so tubes of paint should suffice. It is a good idea to buy a large tube of white as you will probably be using it a lot to lighten the other colours. Two or three brushes should be adequate. A piece of hardboard or plywood found in the garage (or bought for a few pence at your local hardware shop) and primed with household undercoat will make a good first support; maybe later you will want to use canvas or canvas board.

The rest of the materials can be collected from around the house – large jars of water, rags, paper towel, a pencil and an eraser. A large plastic plate or a piece of formica can be used for a palette – preferably white being the same colour as your support it will simplify colour mixing.

The one other piece of equipment that you will want to have is an easel. These come in a very wide range of sizes and prices, from the small wooden table easel to the very large electrically operated roll about studio easel. The best type to buy is the folding easel which can be transported effortlessly, from room to room, to your art class or out on a day's painting trip to the country. They are very moderately priced and are made in wood or aluminium. Putting up the wooden ones tend to be a bit like tackling a deck chair; the metal ones are far more straightforward and have greater stability.

Equipment

PAINTS

Acrylic paint is produced in as many colours as other painting mediums and is available under the same pigment names, for example raw sienna, ultramarine blue, etc. Most manufacturers do produce some colours under their own brand name, such as Talens yellow (Talens-Rembrandt), Rembrandt blue (the same manufacturer) and Winsor blue (Winsor and Newton) etc. You will find, though, that all manufacturers of paints will have equivalent colours; for instance the Rembrandt and Winsor blues are very similar colours. Although the manufacturers produce many colours, it is not essential to have every colour. Most artists work with a limited palette (see pages 28-9); this means that they only use a small number of colours, perhaps eight or less.

When applied to the support acrylic paint has a butter-like texture; used straight from the tube it is quite thick and retains the brushstroke well, although layer thickness may decrease slightly owing to the evaporation of the water in the paint.

Most artists' quality acrylics (there are cheaper varieties) have very good light fastness and mix together extremely well. They can be thinned with water or an acrylic medium, but when dry are water resistant.

The binder, the fluid that holds the dry pigment together, causes no yellowing of the pigment over any length of time and is extremely durable. A problem with oil paint is that the oil binder in time yellows the pigment, altering the colour. On the canvas the acrylic paint film does not change or yellow and is flexible; once dry a painted canvas can even be rolled up, and no cracking will occur, not even after years. Drying time varies from minutes to a few hours, depending on the amount of humidity in the atmosphere and the thickness of the paint.

There are several different types of acrylic paint on the market. Most art material manufacturers produce artists' quality although they do vary in thickness from company to company, some being quite runny. One company does produce a more fluid acrylic, called 'Flow Formula', which is especially designed for covering large flat areas often essential to abstract and hard-edge painters.

A cheaper range of acrylic colours are PVA and vinyls, less expensive because the pigments used are inferior to those used in the artists range. In addition, they are bound together with a polyvinyl acetate resin instead of an acrylic resin. These paints often come in large size tubes and are frequently used by mural painters. Generally acrylic is sold in the standard 40 ml tube but the more popular colours and white can be purchased in very large tubes varying in size from 115 ml to 150 ml.

When starting out with acrylics it is better to buy just a few tubes at a time

and add to them when you need extra colour (see the suggested palette on pages 28 and 29). Large polished wooden boxes with a couple of dozen tubes of paint, brushes etc. may look tempting, but you will find that most of the contents are not what you need. The brushes supplied are too small or too large, paints the wrong colour and so on; furthermore, they cost an awful lot of money.

There are many auxiliary materials to support acrylics. Although they are not essential (just water can be used to thin paint and wash brushes) they do allow the artist to pursue different techniques with the paint. The most useful accessory is a painting medium; this can be bought as a liquid in a bottle or as a gel in a tube. Acrylic liquid medium is a milky-white substance that dries to a transparent and water-resistant finish. It can be obtained in a gloss or matt finish. When using a painting medium the paint film

remains elastic and the colour brilliance is maintained, if not improved. It gives the painting a more transparent effect, producing further depth to the picture. The matt medium has all of the qualities of the gloss, but dries to a matt eggshell finish. The gel medium is of course, firmer than the liquid; it is a clear paste-like material which can be squeezed on to the palette along with the paints, no receptacle is required to hold it. Another medium which dilutes and stretches the paint, but also slows down the drying time, is retarder. The addition of a small amount to the paint lengthens the drying time considerably. The use of retarder is demonstrated on pages 108-111.

To add a relief-like surface to a painting or to produce heavy texture, modelling paste can be used. This can be applied on a non oil-containing rigid surface such as cardboard, wood, canvas board, walls and concrete. When mixed with about 50 per cent gel

medium, modelling paste can also be applied on flexible grounds such as linen and cotton.

To prime boards or canvases before painting, acrylic gesso universal primer can be used, although many people do use ordinary household base coat. Universal primer is more flexible and durable than any other primer and can be tinted with acrylic paints, and also used in the actual painting as a substitute for white if large areas are to be painted. This can be bought in a variety of sizes from small plastic tubes and tins to large gallon (5 litre) size containers. It is cheaper when purchased in large amounts.

BRUSHES

A variety of brushes can be used with acrylics and your choice will depend on the techniques that you are employing. If applying the paint in a watercolour style, you would use watercolour brushes. For most other approaches you would employ oil painting brushes. There are brushes which are especially made for acrylics but if you already have oil brushes they will suffice. Household paintbrushes can be used if tackling a very large painting or mural.

The best watercolour brushes to use for acrylic are those which are synthetic; not only are they less expensive than sable but much harder wearing. Acrylic tends to wear out brushes faster than any other medium. It is not advisable to use very cheap brushes; often beginners will buy inexpensive brushes thinking that when their painting has improved they will buy better ones. The problem is that using a cheap brush will probably hamper their progress. Poor quality, low priced brushes have no spring in them and more often than not the bristles fall out. When buying a watercolour brush make sure it has a good point on it. It is quite acceptable to ask the shopkeeper for a jar of water to dip it in to ensure that the hair comes to a point.

The most popular brushes used by acrylic painters when working on canvas, hardboard etc. are bristle brushes which are made from hogs hair. They are made in four shapes: flat, bright, filbert and round. Flat brushes are square-ended, while bright brushes are flat with rounded tips; the length of the bristles varies. The shapes of filbert and round brushes are self-explanatory.

Choice of brush is personal and depends on your style of painting. Buy only one or two brushes to begin with, a

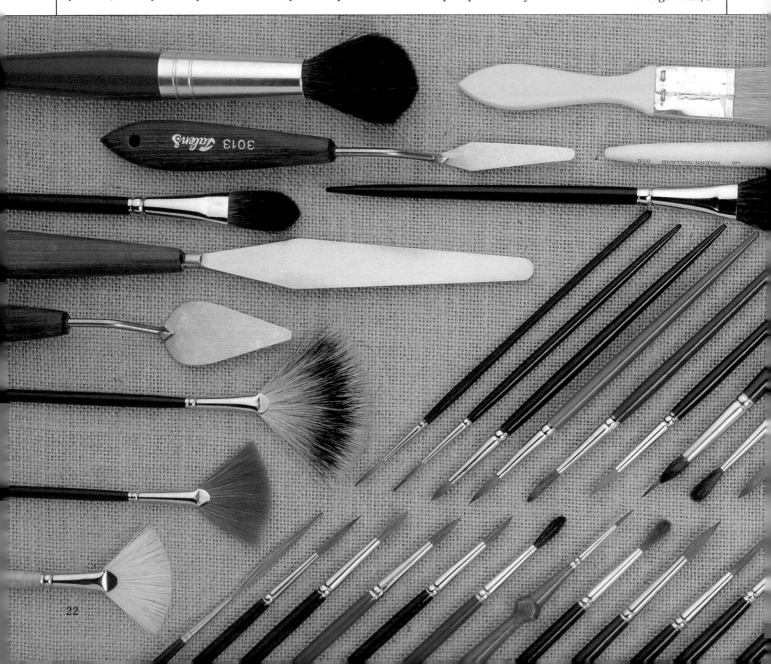

small to medium size and a medium to large, say a No. 7 and a No. 12. As you gain experience you will then know what other brushes you need.

A very special brush, and one that is used quite often is this book, is the 'rigger', or 'script liner' as it is known in America. This brush usually has stable, hair or synthetic bristles which are much longer than the average brush. It is very useful when painting bushes, plants, rigging on ships (from where it gets its name) etc. For a demonstration of its use, see page 74.

Other brushes which are often employed by the artist are sign writers' brushes, shaving brushes (for washes) and even toothbrushes (see page 74). Fan brushes, so named because of their shape, are quite useful both for blending brushstrokes and for painting foliage, etc. There are so many different brushes to choose from and every sort of brush has its peculiarities.

Many artists like to paint with palette knives; these too come in many shapes and sizes and it is through trial and error that the artist must decide which suits him best.

An extremely important point when painting with acrylics is NEVER to allow the paint to dry in the brushes; if you do, the brush will be ruined. When working on a painting keep a large jar of water handy to put your brushes in until you need to use them again. When finished for the day, make sure that you give your brushes a thorough wash with soap and cold water, making sure that you get all the paint out of the heel, the part where the bristles enter the metal ferrule.

SUPPORTS

It is not quite true that acrylic paint can be applied to any surface, although it will adhere to many. It is best to avoid surfaces which contain oil or wax as the paint will peel off when dry. Do not use canvas board or canvas which has only been prepared for oil paints; often this is marked on the back of the boards, so make sure that you check. These days manufacturers usually prime with acrylic gesso which will take oil or acrylic paints.

Many artists work on hardboard; it is usual to prime it but is not essential. If the painting is to be very large, it is best to support the board with a wooden frame (simple wooden strips attached to the back). Both sides of the hardboard can be used, although mostly it is the smooth side which is painted on. To prime hardboard, first give it a light sanding with fine sandpaper. The first coat of acrylic gesso should be mixed with half water so that it absorbs more readily into the board. When this is dry is should be lightly sanded and then painted with full-strength gesso, the brushstrokes all going in the same direction. When this has dried the procedure should be repeated, with the brushstrokes going in an alternative direction. Raw canvas which has been attached to stretchers can also be

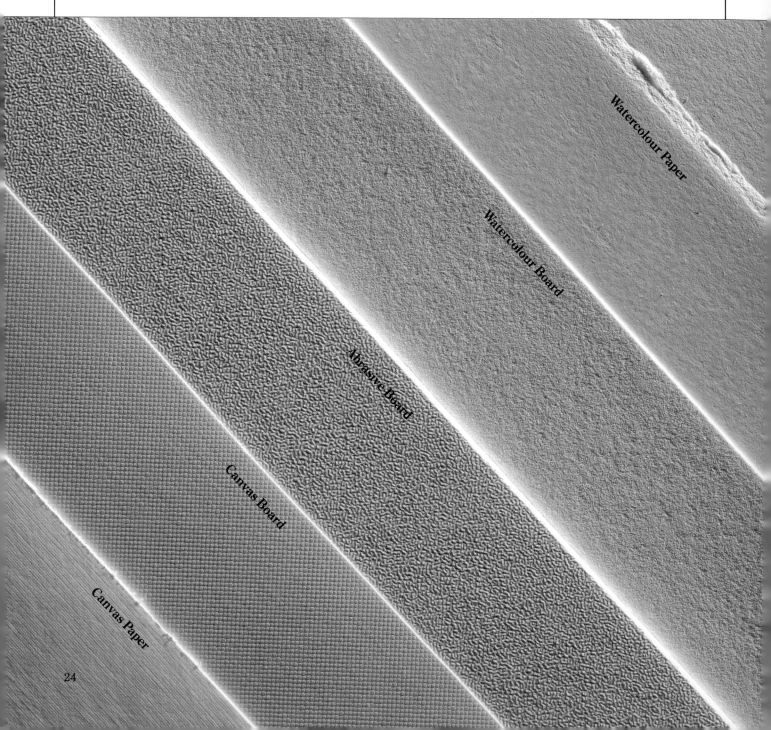

Watercolour Paper

Watercolour Board

Abrasive Board

Canvas Board

Canvas Paper

primed in this way.

Other surfaces that will accept acrylic paint are cardboard, plywood, chipboard (all can be primed in exactly the same way as hardboard). Any untreated cotton or linen will accept acrylic as well as wood, plasterwork, earthenware or concrete. On surfaces which are highly absorbent, dark, smooth or uneven, it is advisable to apply a coat of gesso acrylic primer.

Of course, if the paint is to be used in a watercolour technique, then a suitable paper will be needed. Watercolour paper comes in several different surface textures: 'hot-pressed' which is very smooth, 'not' which means that it is not hot-pressed and has a slight texture, and 'rough'. There is quite a variety of surface textures in 'rough' paper, varying from slightly rough to very rough. Watercolour paper also comes in

several different thicknesses depending on its weight; 45 lb (100 g) is the thinnest and really is too flimsy to paint on. Other weights are 70 lb (150 g), 90 lb (200 g), 140 lb (300 g) and so on up to 500 (1000 g) or 600 lb (1300 g) which is very thick. An advisable weight to use is 190 lb (400 g); it is fairly robust, will stand up to quite a lot of working and will not need to be stretched.

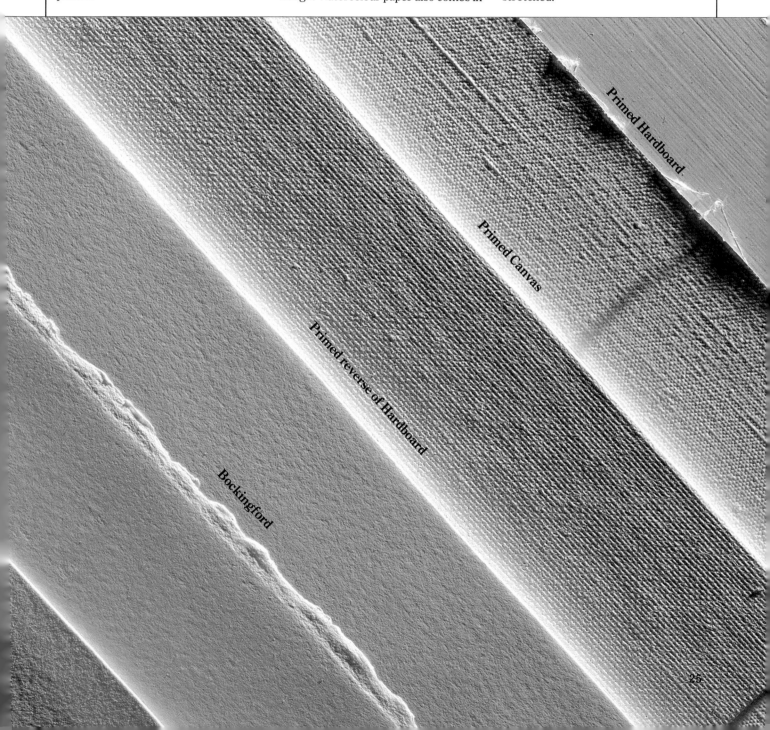

Primed Hardboard

Primed Canvas

Primed reverse of Hardboard

Bockingford

Chapter 3
Looking at Hue

Colour or Hue is the artist's most important tool; without it he is very limited. Knowing how to make it express an emotion or action is very satisfying to the artist. Colour can add depth to a painting or bring things closer, create atmosphere or describe a mood. Used creatively it offers endless possibilities.

In this chapter, we suggest using a limited number of colours, the reasons for using each and what they can do for you. Following this, the spectrum is discussed and described in a fairly simple manner, complementary colours and their uses are explained. This is a very important area when learning to paint and it is worth spending quite some time experimenting for yourself; doing so will take a lot of the guesswork out of colour mixing.

There are several terms used in art to describe colour and this seem to cause a lot of confusion. It is quite important to understand these terms as they will occur often, not only in this book but in other art books you may read or conversations about art you may hear or have.

Value
The lightest colour the human eye can perceive is white, the darkest is black. There are countless shades of grey between these two extremes. Every colour has literally innumerable shades. The relationship of any of these shades to black or white is what we call the value of the colour. The closer a colour is to white, the higher its value. The closer to black, the lower its value. Blue, red, brown, green, orange, pink and so forth are different hues but they can all be of the same value, or each colour can have many values. The value of each colour is of great significance in painting.

Warm and Cool Colours
Reddish and yellowish colours are considered warm because they remind us of fire and flame. Bluish and greenish tones are cool because they are reminiscent of ice. Thus, colours containing a larger proportion of red or yellow are warm colour while those with a greater amount of blue or green are cool.

BASIC PALETTE

An artist's palette is not just the piece of wood he squeezes his colours on to, it is his actual section of colours. Most painters work with a limited palette; that is, a few colours carefully selected. An individual artist's work can be recognized by the colours he has used as well as his style. The beginner will learn a lot about mixing colours by sticking to a limited palette and with experience will know intuitively when he is ready to add a new colour, take one away or exchange one colour for another. Using a limited palette makes it easier to keep colour harmonies in hand.

The colours shown on these pages are the ones which are used throughout this book; together with white they make an ideal palette for you to begin.

From top left to right:

Burnt sienna
Perhaps the most useful colour on the palette. Mixes with other colours to produce many earth hues: bricks, tiles, wood, terracotta, copper, ground, etc. Also very useful in skin tones and a little is effective when added to ultramarine blue and white to produce a grey blue sky. This is a semi-opaque colour so not recommended for glazes.

Raw sienna
Another earth tone used a lot by landscape painters. Also useful in some skin tone mixtures. This is an opaque colour so has great covering qualities.

Rembrandt blue
A greenish blue, a very strong staining colour. Makes a good summer sky blue when mixed with ultramarine blue. This is transparent and good for glazing

Raw sienna

Burnt sienna

Sap green

Talens yellow

Ultramarine blue
A primary blue and perhaps the truest blue of all the pigments. It makes a very useful grey when mixed with burnt sienna, producing a very light tone when mixed with large proportions of white or very dark, almost black when no white is added. A transparent glaze applied over the background of a landscape will give the impression of distance.

Cadmium red
A bright primary red, very similar to vermilion. Very useful for mixing skin tones, makes a very delicate grey when mixed with Rembrandt blue. All cadmiums are opaque.

Lemon yellow
A primary colour, a cool yellow which can be warmed by adding a small touch of cadmium red. Also mix it with cadmium red to make a bright orange and with sap green to produce a very delicate spring green. This colour varies from transparent to semi-transparent depending on the manufacturer.

Carmine
Useful for mixing with ultramarine blue to produce a strong violet. Mixed with white it makes a delicate pink, but not for use in skin tones.

Talens yellow
A ready-made orange, makes a good glazing colour as it is transparent, will bring forward and add warmth when applied very thinly over the foreground.

Sap green
A soft transparent green, useful alone for springtime foliage. Produces a beautiful misty grey green when mixed with ultramarine blue and white

Ultramarine blue

Rembrandt blue

Cadmium red

Carmine

Lemon yellow

THE SPECTRUM

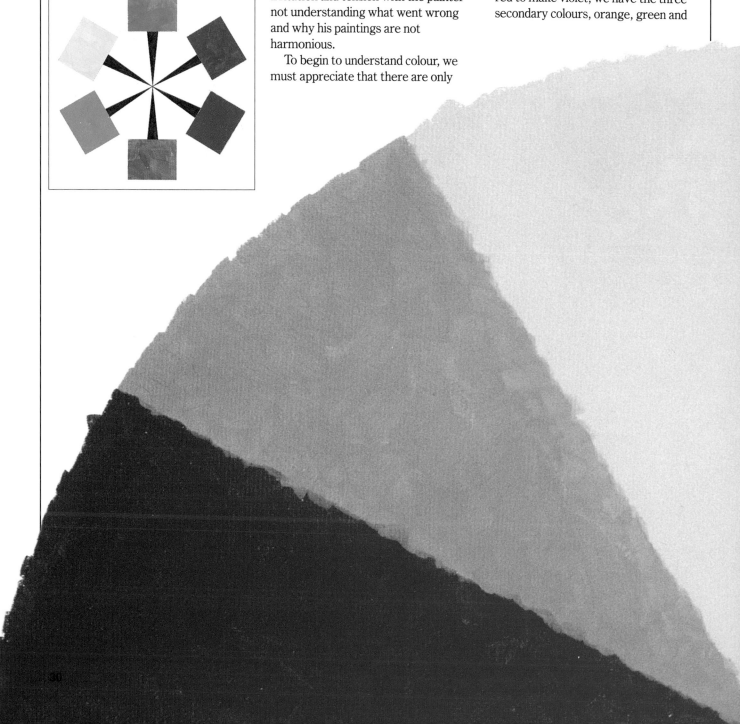

To the artist, colour is a means of expression. It has a direct and powerful influence on our lives and emotions, it surrounds us; when our eyes are open we see colour. For these reasons alone, it makes sense that the artist spends some time studying and understanding colour and how he can use it to express mood and atmosphere, to stimulate or to provide tranquillity. Learning a few basic rules will eliminate a lot of the frustrations that the beginner experiences. Additionally using a limited palette (see pages 28-9) and experimenting with the chosen colours will prepare you for more demanding work later. A lack of knowledge will produce only unsatisfying work, paintings that will cause feelings of irritation and tension with the painter not understanding what went wrong and why his paintings are not harmonious.

To begin to understand colour, we must appreciate that there are only three true colours: red, yellow and blue. These we call primary colours and with them we can make any other colour except, of course, white which is not actually a colour. If we set out the three primary colours in a triangle, one at the top and two at the base in any order and we mix adjacent colours, that is we mix red and yellow to produce orange, yellow and blue to give green, blue and red to make violet, we have the three secondary colours, orange, green and

violet, which we place in between their parent colours. If you have set out your colours in a similar manner to the small diagrams on these pages, you will have constructed the spectrum or the colour wheel as it is often called. You could go further to develop tertiary colours, that is mixing any two secondary colours together, but by doing so your chances of ending up with a mud colour are very likely, as by mixing two secondary colours together you are mixing all

these primaries in different proportions.

At this stage you are probably asking yourself why, if there are only three real colours and I can make any hue with them, do I need to buy more? The answer is simple: convenience. Colours that are used very often, such as raw and burnt sienna are easier to buy ready made than to spend a lot of your valuable painting time mixing them. It also depends on the three primaries you choose from the large range of reds, yellows, and blues, as to the particular colours you can mix. The three that the artist uses are cadmium red, ultramarine blue and lemon yellow. This

red, mixed with the blue, does not produce a satisfactory violet, however, and so the artist used carmine, which mixed with ultramarine blue, does. Ultramarine blue and lemon yellow do not make shades of blue green and so the artist added Rembrandt blue to her palette.

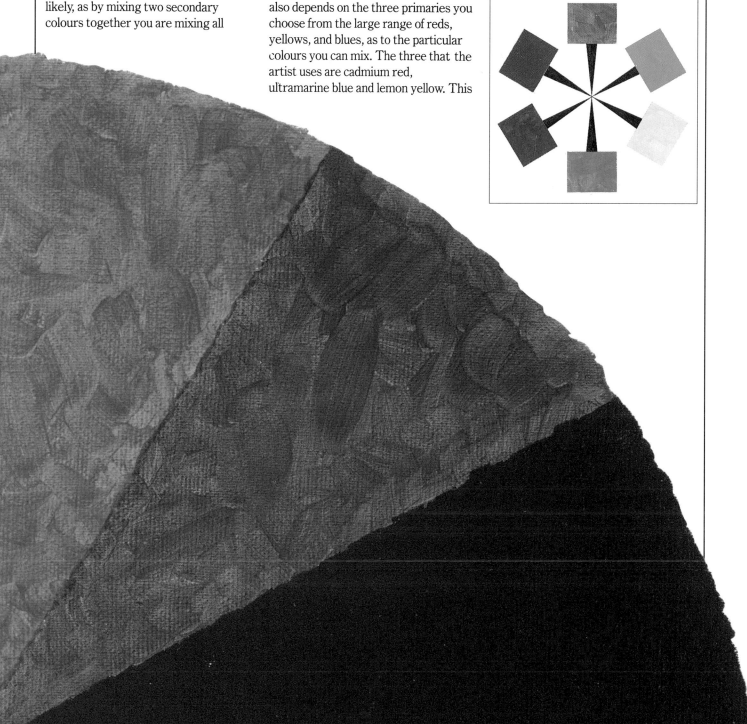

COMPLEMENTARY COLOURS

With the spectrum in front of you, you will notice that red is opposite to green, yellow is opposite violet and orange opposite blue. It doesn't make any difference in what order you set your triangle of three primary colours, the same opposite will always occur. These opposites are called *complementary* colours, and to achieve satisfaction in your painting you need to have an understanding of complementaries and how they can help you.

One of the first problems that we encounter when beginning to paint is that we do not know how to tone down our bright colours. We add a little black and it looks too dull, so we add a dab of something else and before you know it all you have on the palette is mud. This is where the use and knowledge of complementary colours begins, and the rules are simple. When a colour is too intense, add a little of its opposite colour, its complementary. For example, to tone down yellow, we add a little violet, for red we add green and so on.

In contrast to muting colours, complementaries will also intensify them. Rather than mixing the two colours, however, we place them side by side. Paint a strip of blue next to a strip of orange; the blue look bluer and the orange looks oranger. This theory was used by the Impressionist school around the middle of the last century and further developed by the Post-Impressionists. Paul Cézanne was the first artist consciously trying to achieve effects by juxtaposing certain colours. He found that a lemon looks brighter with violet blue next to it and a red apple appears to be more brilliant on a green cloth. Likewise, by adding touches of red to foliage, grass, etc. you will find that it appears to shimmer more and the flatness will disappear.

'What colour is a shadow?' is a question often asked by students who frequently use the same tube of grey paint for everything, thus producing uninspiring works. The colour of a shadow depends on the colour of the

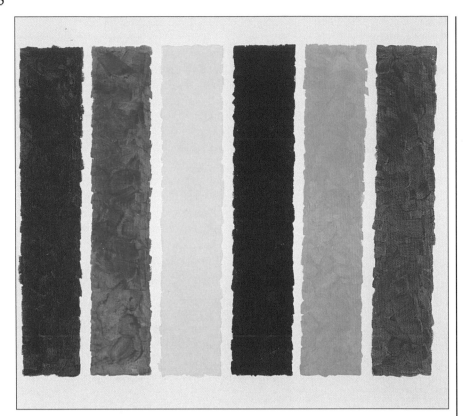

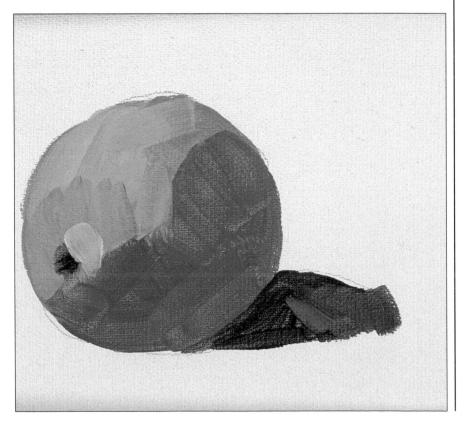

object and the light. The examples on these pages show how complementary colours have been used on the dark sides of the fruits to produce a shadow – green on the red apple, blue on the orange and violet on the banana.

Further to these uses of complementary colour is the mixing of greys or neutral colours. To do this mix any two complementaries together. Red and green will create a brown, orange and blue a grey and so on. To vary the tone and value of colour, the painter must vary the amounts of each colour he uses in the mix.

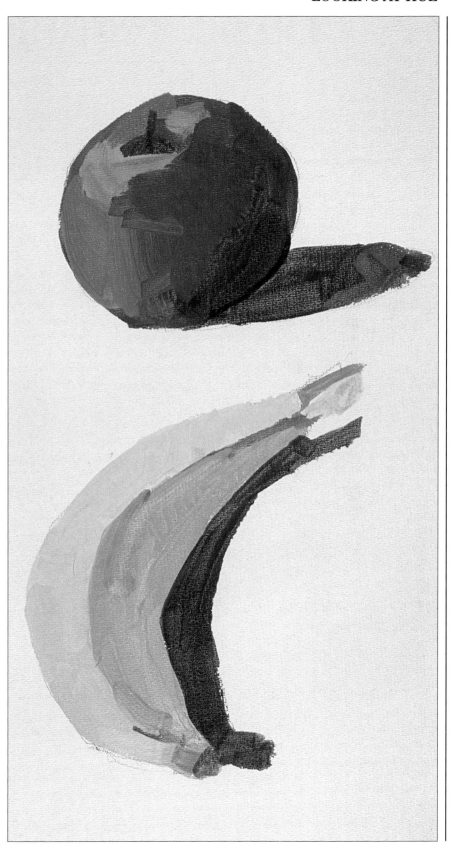

In the three paintings of fruit complementary colours are used in the shadows blue on the orange, green on the red apple and violet on the banana.

Chapter 4
Basic Techniques

While the artist using acrylics can produce paintings as delicate as the Victorian watercolour to large, bold, flat abstract paintings, brushstrokes can be just as varied. Large areas can be smoothed out to appear completely flat and devoid of strokes or the paint can be applied thickly straight from the tube, allowing ridged brushmarks to remain. Many tools other than brushes can be utilized to apply acrylic paint – sponges, knives, pens, the fingers. Perhaps you will experiment and come up with some new ways of applying it.

Acrylic can also be used in building up a collage. Tissue paper, old torn-up paintings or cloth can be glued to a support with acrylic medium, either flat or crumpled. After the medium is dry and the material held in place, acrylic can be painted over and then perhaps more material, paper etc. added. Very interesting and colourful collages can be created in this way.

It is a good idea for the artist in any medium to keep a source file. That is, to collect pictures and pieces of pictures from all kinds of sources and to file them away for future reference. They can be collected from newspapers, magazines, your own sketches, or photographs (your own and others). These references are not to copy, but to help you when composing a picture. For example you may be painting a rural scene and want some cows to complete the picture. This is where your reference file comes in handy. Further to this, you may want just to stick the picture of the cows on to the painting; with acrylic this is possible. Just coat the back of the picture with acrylic medium and apply it to the painting. When it is dry, just paint over with more medium and your cows will be fixed forever in place. This type of art, combining painting with photographs or stuck-on cuttings, is called montage.

If mistakes are made in any form of acrylic painting, it is very easy to correct them. When the area that is wrongly painted is dry, simply paint over the top of it, or completely blank it out with white paint and begin again.

Acrylic varnishes are available in art shops in both matt and gloss finishes but they are not essential; acrylic medium will accomplish the same job. A thin coat after the painting is finished will bring all areas up to the same gloss or matt finish, and if at later date you wish to change the image, there will be no problem in working over this varnish and then revarnishing.

Basic Techniques
BRUSHSTROKES – APPLYING COLOUR

1 One would think that applying paint with a brush is an easy task – just slap it on. But, not so. Brushstrokes are the means by which the artist expresses his personality, through paint applied with thought and care. There are many ways of applying paint, and a few are illustrated here to get you started. Eventually you will develop a brushstroke which is as unique to you as your handwriting.

Here the artist, using a fairly large brush, cross-hatches the paint. That is she paints a stroke in one direction and then turns the brush to cross back over the first stroke.

2 The brushstrokes in this demonstration are all going in the same diagonal direction. This technique was employed by several of the French Impressionist painters in the nineteenth century.

Whatever technique you employ stick to it throughout the painting; do not change stroke mid-stream, but aim for a unity in your technique. Using different brushstrokes from one area of the painting to another will fragment your work just as introducing odd areas of isolated colour will. If you are using descriptive brushwork, following the form of your subject as Van Gogh did, then make sure that you complete the whole painting in this way.

3 This technique is produced with a stiff bristle brush. With paint it is used to depict grass, rough ground or foliage. To achieve this the brush is sometimes pushed up against its bristles and other times used upwards in a flicking motion. Another way is to use the brush in a scrubbing motion to apply the paint.

4 Scumbling is a method whereby you can soften or blend with an upper coat of opaque colour, applied very thinly. You can also produce an effect of broken colour by exposing the colour below the top one. This technique employs quite a dry bristle brush with a little paint on it dragged over another colour. This is very useful for creating texture, a dark colour being dragged over a lighter one. It is a technique often employed by landscape artists to depict old fences, tree trunks, roads, etc. Portrait painters often use scumbling, too, when illustrating hair.

SOURCES OF INSPIRATION

Working from Photographs

There is nothing worse than going into an adult art class and seeing the students meticulously copying chocolate box postcards. Unfortunately this sort of activity has given photography a bad name as far as the artist is concerned, and this is regrettable. Photographs used in the right way can be a great asset to the painter. It is most important only to use photographs that you have taken yourself of objects or, if taken by other people, of subjects that you are fairly familiar with. Perhaps when on holiday something you see really inspires you but there is no time even to make a sketch, then by all means photograph it. The next step is not to copy it exactly but to make several sketches from the photograph, add objects, take things out of the picture, simplify the composition. Now put the photograph away and be creative with your colours. Perhaps you will turn a winter scene into summer, or add a different background. Whatever you do, do not become a slave to the photograph and do not be afraid to experiment; the snapshot should only be your initial inspiration, your take-off point.

Sketching

There is no substitute for sketching, for this is where the artist gains his memory bank, his store of images. Use of the sketchbook cannot be emphasized too strongly. The sketchbook notation is important under any circumstances. It avoids the pressure of time, but serves for jotting down a movement, line, a group of shapes or even the behaviour of light. The student artist should never be without his sketchbook. When preparing to execute a painting on location or in the studio, the sketchbook is an important item. Time spent working out the compositioning, sketching the subject from different angles, will in the end produce a more satisfying image to the artist.

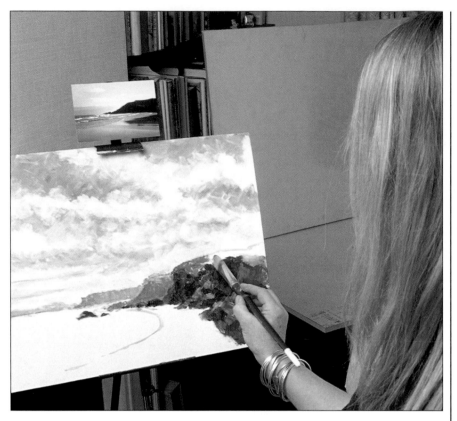

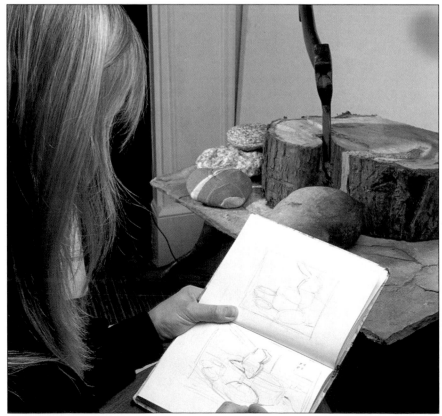

Composing a Still Life

Good material for still-life painting is everywhere; no one need go in search of a subject. Look in the kitchen at the pots and pans, copper and brass, glass bottles, fruit and fruitbowls; the choice is endless. What about the shed, the garage or the garden, even the attic? These places are filled with objects just waiting to be portrayed. Actually choosing a subject and setting it up is absorbing and enjoyable; this is where the creativity process begins. Select objects and shapes that interest you – an old pair of favourite shoes, a musical instrument, plants or flowers. Whatever you choose, be sure that the individual objects relate to each other, kitchen pots and utensils with vegetables, or sea shells next to a bucket and spade. Make sure also that the background has an affinity with the subject, flowers in a vase on a window ledge, toys in the toy cupboard for example.

Whatever you choose, it is unimportant as far as the painting is concerned. An exciting picture can be made of a cabbage, and a dull one of a leaping horse.

Painting from Still Life

Once you have chosen your subject and sketched it, working out your composition in your sketchbook, you are ready to paint. The discipline of still-life painting can be very rewarding in your progress as a painter and can be just as exciting and pleasurable as landscape or any other type of painting, with less hazards. Working in the studio away from the distractions of the wind, changing light and people, you are able to concentrate on the problems of drawing, composition and the selection and mixing of colours.

Many artists throughout history have been influenced by the disciplines of still life. By studying these either in museums or books, you can gain inspiration and ideas for your own paintings.

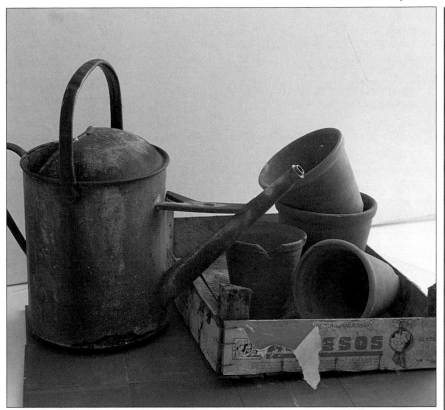

TECHNIQUES – MAKING A CANVAS

Making a canvas does not demand a lot of time, is quite easy to do, cheaper than buying ready-made canvases and, above all, an enjoyable preparation to painting. By shopping around, you can buy canvas at a reasonable price: many mail order art companies sell it at a discount. It can be purchased in linen (this being the best) and cotton – from coarse heavy fabric, suitable for large landscapes, to very fine close weave for portrait painting. Non-multipurpose is not suitable for acrylics, and only use canvas that has been pre-coated with gesso. Stretcher – the wooden frame that the canvas is attached to – can be purchased in all lengths, usually in 2 in (5 cm) intervals, for example 16 in (40 cm), 18 in (45 cm), 20 in (50 cm) etc.

1 The tools needed for making a canvas are a hammer, scissors, staple gun or tacks and a tape measure. A carpenter's hammer is handy, as is a small block of wood.

2 The stretchers are put together; usually they can be attached by hand, a tap of the hammer afterwards securing the corners well into place.

3 Measure the frame diagonally in both directions. Checking that the measurements are exactly the same will ensure that the corners are perfectly square.

4 Place the stretcher frame on to a piece of canvas, allowing a 1½ to 2 in (3.75 to 5 cm) cut all around.

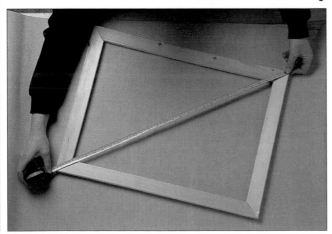

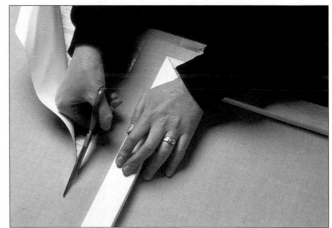

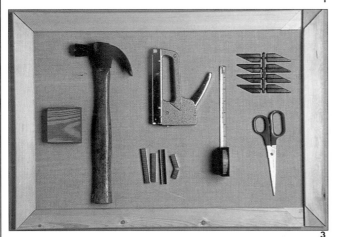

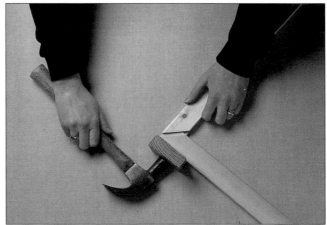

5 Beginning from the centre of one of the longest sides, staple or tack the canvas into place, move to the opposite side, pull and staple. Work all the way around the canvas in this manner, moving from side to side, omitting the corners.

6 Bend in the point of the corner creating two ears.

7 Flatten the two ears to form a flat diagonal line, and put two staples across this seam.

8 With the corners finished and the canvas stretched, now is the time if you are using raw canvas to prime it. Three coats are advisable.

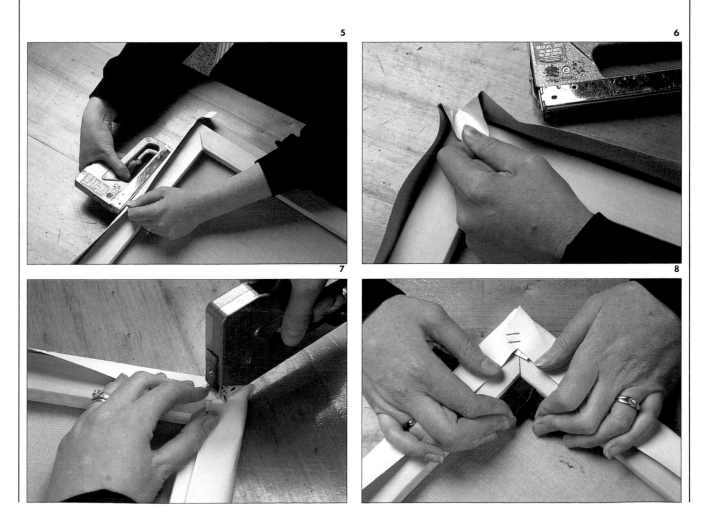

Chapter 5
Exploring Acrylics

Acrylics can be applied to any non-greasy surface, which in itself gives a lot of scope. Paper, cardboard, wood, canvas, tin, glass, even walls, are all exciting and possible supports. As for techniques, acrylics can be used quite simply just by mixing them with water and employing them like poster paints, or you can experiment with them to their fullest potential. Use them like watercolour in thin flat washes, try them straight from the tube as thick impasto oils, mix them with a medium and glaze, or use larger brushes and paint a mural size picture.

The problems encountered when learning to paint with acrylics are basically the same as with any other medium – difficulty with composition, perspective and colour etc. But as far as the actual materials are concerned, if comparing oil, watercolour or acrylic, then acrylic is far the easiest medium of all to handle.

Learning a few simple rules about painting is a help in the beginning and once you begin to break the rules it will be an indication that you are becoming more proficient. When you

begin, choose a familiar subject, something that you see everyday; it will help as you will already have a good idea of the required shapes.

It is quite important to be able to draw but with practice this will come, try using a sketchbook whenever you have a spare moment. Don't be afraid; every stroke that you make with the brush is a step in the right direction. Painting, it is often said, is drawing with a brush. Practice makes perfect.

In this chapter we shall explore not only handling acrylic but also some of the basic points of putting together a painting, composing a picture. We shall discuss the basics of form, the shape of your proposed painting and the positioning of the focal point in a composition, with some guidelines on how best to use the available space. Perspective, both linear and aerial (colour) is an enormous subject which many students find daunting, but this is covered as simply as possible. With a little understanding of its principles you will find that you look at things differently and will feel more confident in translating them into paint.

FORM

Form is a device that artists use to explain the shape of the images in their work, whether they are representational or abstract. To make form more understandable, the artist employs light and dark. When a painting is of one value, no lights and darks, we say it is 'flat'; it has no form. When an object is lighted from one side by the sun or artificial light, this means the delineation of form is expressed by sharp contrast of light and dark. This effect is shown and formalized by means of at least three values. The diagram on this page demonstrates this in monochrome; the image is made up of a light, middle and a dark tonal value. These values explain the shapes of each object clearly. On the opposite page, the same diagram is shown, but this time in colour. The values are still the same, just the hues are different – the darkest areas of the blue, green, red etc. are equally as dark. On the square objects note that the colour value, light or dark, stops at the sharp edge where there is a definite change in direction, whereas on the round objects the curves are continuous and gentle. The darkest and lightest areas do not finish as abruptly nor do they continue to the edge of the drawing because in reality there is no edge on a round object: it is not a flat

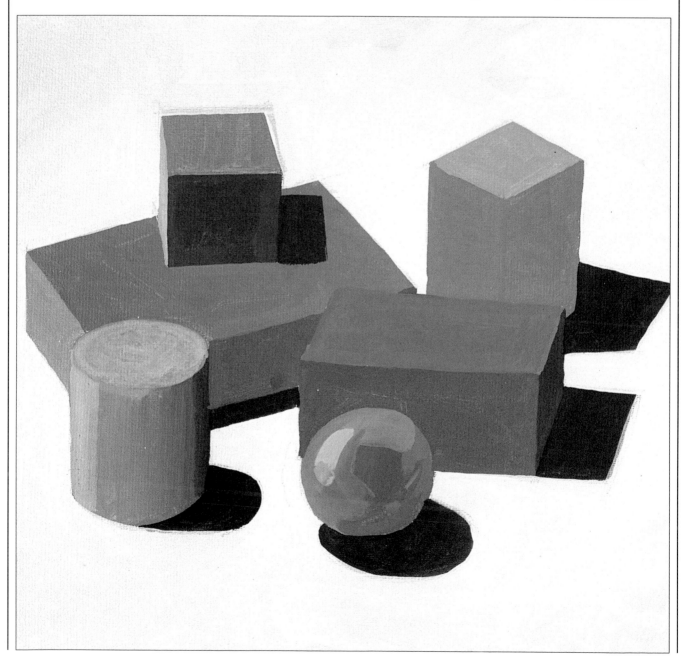

shape, and so there is always a reflected light coming around.

We do not see form; we see only one surface of an object as we see a photograph, flat. Learning to draw solid shapes is almost a re-education of the senses. Since we were born, we have been touching objects, feeling their shape, walking around the back, so trying to see things as flat shapes is a new idea to us.

You can learn to compose with forms as well as with lines. Objects may be placed in relation to each other by means of light and dark to show their position in space – a dark object placed against a light one, or a dark background for a light subject. The painter's problems are similar to those of the sculptor; the artist refers to weight, modelling, finding the form and other terms which have to do with the

appearance of actual solid forms, with the difference that painting is just a set of symbols on a flat surface which are recognizable to the observer.

The shapes of these objects both in black and white and colour are easy to recognize as value is used to describe their solidity.

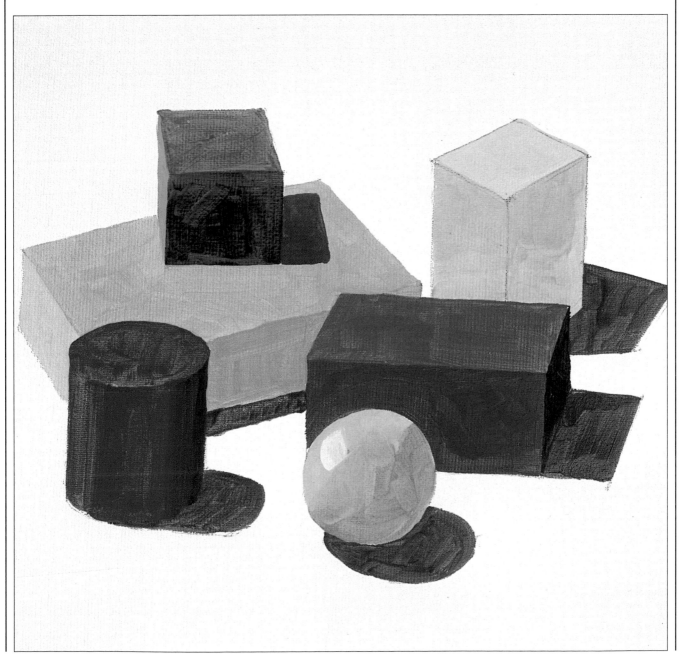

COMPOSITION

Compositional standards and ideas change from artist to artist and year to year. Some artists will forget all rules of composition. Here we suggest a few basic rules to use as guidelines in the placement of an object. In the first picture the vase of flowers and the table seem to be falling off the left side of the support. Altering the angle of the top right corner of the table and carrying the line to the lower right side of the canvas would remedy this.

The second picture shows the vase seeming to disappear off the bottom of the picture, showing the whole vase would have been better.

In picture number three the subject is too close to the bottom and the right side of the canvas and the edge of the table leaves the support at a corner forming an arrow which leads the eye out of the painting.

In the last picture, the vase is well placed on the table. The table leaving the support on three sides, anchoring the image on the picture. A well-knit composition holds the eye within the surface of the picture plane.

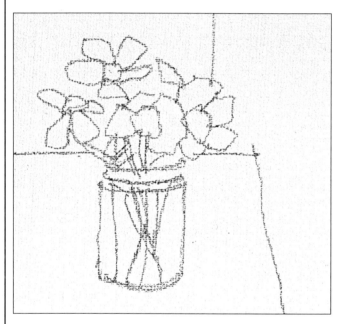
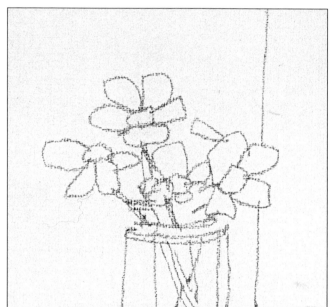
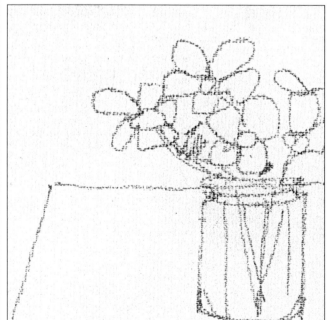
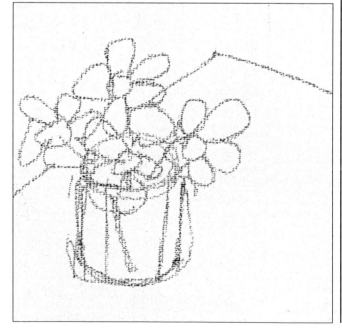

Positive shape refers to a space completely enclosed by a contour. The empty spaces between distinct forms are often referred to as negative space. The problem in painting is not defining the terms but how to recognize negative areas and transform them into positive shapes. All space on the painting surface must be positive. The artist must work towards encompassing all of the allotted space within some form of contour and holding that space within the boundary lines of the painting. The eye must never be forced out of the picture by negative areas; all parts must hold the interest of the viewer with line, texture or colour.

In the first illustration the subject (positive space) has been removed to leave the background (the negative space). In a profile portrait, when the face is looking decisively one way, the space that the model looks into is positive and the area behind the head is negative. For this reason, much more space should be in front and very little behind.

One must be careful when composing a painting not to clutter negative space with incidentals, stones, tree stumps, etc. This very often emphasizes the negative space, making it appear fragmented.

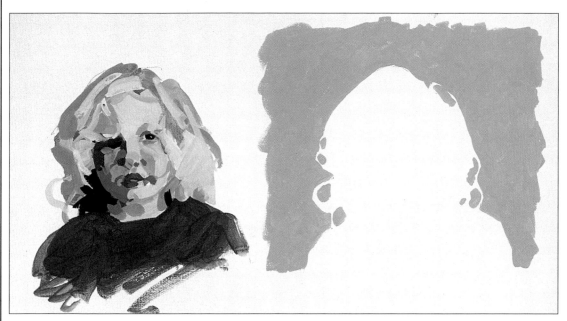

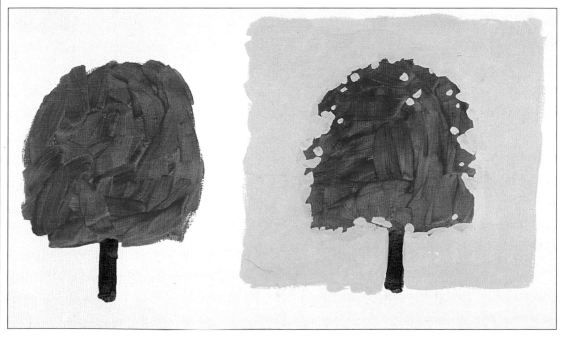

AERIAL PERSPECTIVE

Sometimes called colour perspective, this is the art of creating the impression of distance in a painting and bringing the foreground close.

When standing on high ground and looking into the distance to hills and trees, we notice that the further away the range of hills, the lighter they look; very often the furthest hills will look only a shade darker than the sky. This is especially noticeable on a summer evening when the mist is rising, or early in the morning. Looking into the distance one sees layer upon layer of trees – all in flat shades of grey, a tonal picture in itself. To give the illusion of depth in painting the artist must capture this phenomenon created by the moisture and miniscule dust particles in the atmosphere. In the distance, details of hills, meadows, houses and trees become vague and colours fade. Each colour becomes bluish, sometimes almost violet. You can still distinguish between a meadow and a wooded area, or between a winding road and a winding river, but distant scenery resembles something covered by a light blue veil on a sunny day. To keep colours in perspective the painter should save the brightest and strongest colours for the foreground.

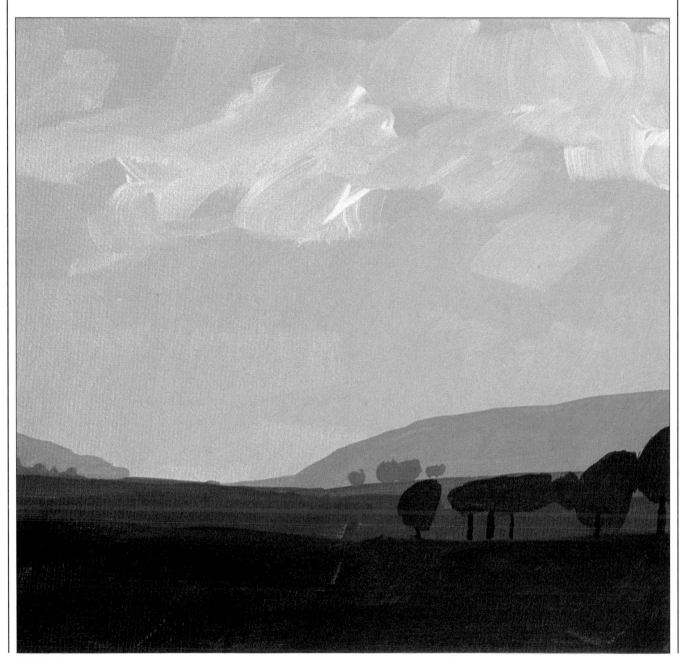

To draw a three-dimensional object on a flat (two-dimensional) piece of paper, some knowledge of linear perspective is essential.

We do not see objects, angles and lines as they actually are. They diminish in size as the move into the distance. Hold a pencil in front of your eyes and look down a street, corridor or long table, then measure the width of the distant end along your pencil and then measure the closer end and compare the two. You will find that the closer measurement is far greater than the distant. This is how we must draw it although we know in reality that if we actually measure the table top, it will be exactly the same width at both ends.

But to produce a convincing picture, we must draw as we see. Parallel lines (the edges of the table, sides of a road, etc.) never actually meet, but in perspective, the way we see them, they seem to. They always meet at our eye level, which in art terms is called the horizon. The point at which the parallel lines converge on this horizon is known as the vanishing point. Our horizon line corresponds with our position. If we stand up to draw it is higher than if we sit down. This is, of course, because we are altering the level at which we see, our eye level. Parallel lines below our eye level come up to it; the horizon and parallel lines above our horizon come down to it. The drawing on this page shows that the artist's horizon (eye level) was at the top of the ground-floor windows. Here we can run a straight line through the picture; all lines below this horizon come up to it and all lines above come down.

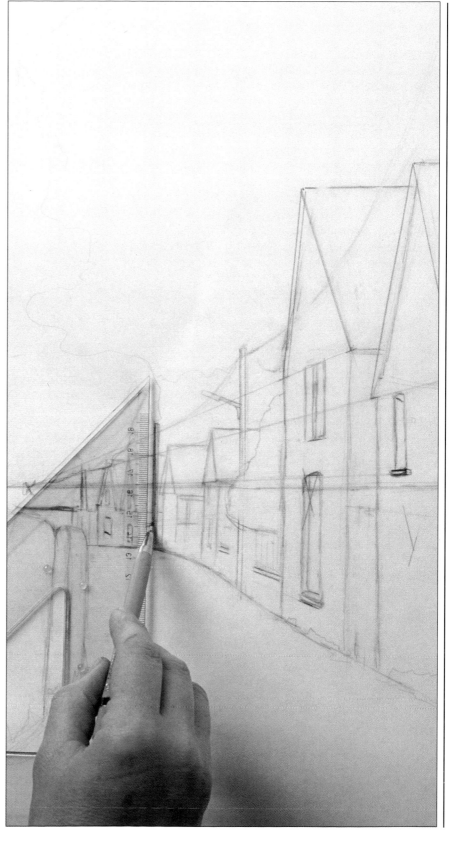

Using a right angle triangle the artist checks the vertical lines in the drawing.

Watering Can and Flowerpots

EXPLORING ACRYLICS

The ellipse shape (the elongated top or bottom of a round object) almost always enters the world of the beginner painter at an early stage.

Here we explore the putting together of ellipses along with other shapes and compose a picture of simple objects found around the home. Tea cups and saucers could be used though they would probably be more difficult because of the handles, but any objects of simple shape found in the home can be used for this demonstration. Man-made round shapes (pots and watering cans) and a square shape (box) were chosen because they are perhaps the most common of all shapes that we see around us.

Choose the support (board or canvas) on which you are going to work so that it suits your subject. A tall narrow support will not contain a square subject – that is, where the subject's height is the same as its width. Likewise, a square canvas will not suit a subject such as a long thin figure or landscape, so choose your support carefully.

Once you have the surface on which to paint the next problem is where to begin. If you draw the largest or most important object on to the board, placing it where you instinctively feel it goes best then it is easier to relate all other objects to this, comparing size and looking to see how far up, down or across the additional objects will be in comparison to the shape which you have already drawn.

The painting of the pots and watering can is built up in quite a simple way – first the drawing, then building up the painting, middle tone (colour) first, then dark and finally light areas.

If using acrylic paints for the first time here are a couple of hints which you may find useful. First, it is a good idea to use a plant atomizer (the type used to humidify plants) to spray the paints squeezed out on to the palette. Doing this every fifteen minutes or so will keep the paint moist and usable for a much longer period of time – acrylic paints tend to form a skin over them if allowed to dry. Second, it is important to have two or even three large jars of water by you at all times as the brushes must be kept in water when not in use – acrylic plaint allowed to dry in the brushes will be almost impossible to remove. Always give the brushes a thorough clean at the end of a day's painting.

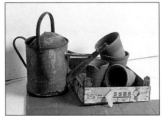

Materials: Canvas board 20 in × 24 in (50 cm × 60 cm); brushes – Nos. 2, 7, 10 and 12 flat; disposable palette; water sprayer to keep paints moist on the palette; 3 large jars of water; rag or paper towel.

1 This subject was chosen by the artist to demonstrate the use of common shapes – circles and squares – found in our everyday environment. Displayed in a good light, the subject can easily be divided into three tonal values – light, middle tone and dark.

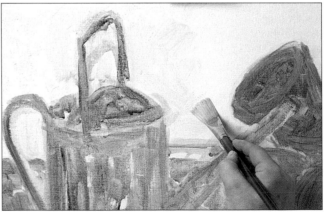

2 The objects are drawn on to the canvas using a No. 7 brush dipped into burnt sienna greatly diluted with water. Drawing with a brush is much simpler than it perhaps seems, it allows a lot more freedom than using a pencil or charcoal. If a mistake is made it can quickly be wiped out with a damp rag. Don't be afraid to paint large; draw the biggest object first and relate all other shapes to it. When drawing ellipses, take your stroke the whole way around as it flows much easier than just drawing a part; you can always wipe out the part that doesn't show.

3 Satisfied with the drawing, the artist squeezes out the rest of the colours to be used on to her palette, giving the paints a quick spray with the atomizer to keep them moist. Using a No.10 bristle brush and diluting the paint, the middle tone colours of each object are blocked in.

Ultramarine blue and burnt sienna are mixed for the watering can, cadmium red and burnt sienna for the pots and tiles. Raw sienna is used for the wooden box, the front being painted in lemon yellow which is carried through for the background.

4 With an even layer of thinnish paint over the whole canvas, all areas are blocked in, including the tiles on which the objects are standing. The artist now begins to apply the darks – first to the watering can, using a stronger mixture of ultramarine blue plus burnt sienna straight from the tubes and applying it with a brush dipped into water.

5 Using a No. 10 brush the artist applied the darks to the flowerpots. The mixture used is cadmium red light, burnt sienna and ultramarine blue. In this detail you can see that the brushstrokes are quite free – try to achieve this yourself.

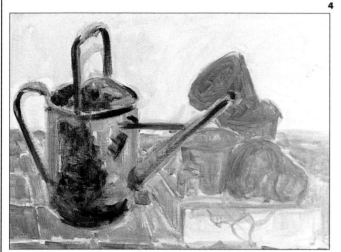

6 The painting is now beginning to take shape; all the darks have been added including some shadow areas. The darks in the yellow areas were painted in violet – a mixture of ultramarine blue plus carmine. A great way to distinguish between light and darks is to look at the subject through squinted eyes. Doing this makes the darks appear to be darker and the lights much brighter, leaving the middle tones quite flat. At this stage the shape of the tiles has been emphasized by adding darker paint.

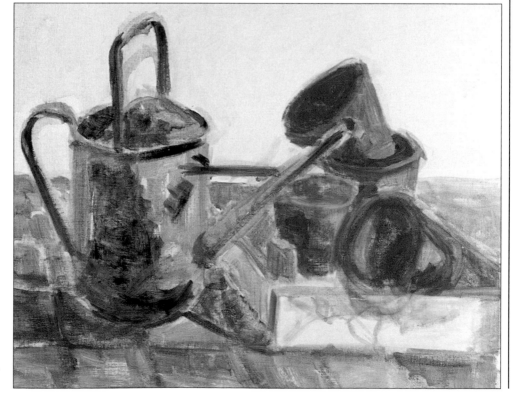

7 Now the subject is looking recognizable we can begin really to paint, building up the layers. Here the artist has added white to her palette, painting the background with a No. 12 bristle brush in cross-hatching strokes. The paint used is lemon yellow, and a little violet (made from ultramarine blue plus carmine) mixed with a lot of white. Be careful not to over mix on the palette, allow the paint to mix as you paint and remember to spray your paints on the palette with water.

8 The artist brings the background well over the objects, making sure that she leaves enough showing to indicate their edges. By the time the flowerpot is painted the background will be dry (the beauty of acrylic) so there will be no fear of a muddy mess.

9 The background colour is brought down to the tiles which are levelled up by painting over the edge of them. It helps to work from the background to the foreground and to overlap the paint on to objects in front so as to avoid white gaps all around each shape or object.

7
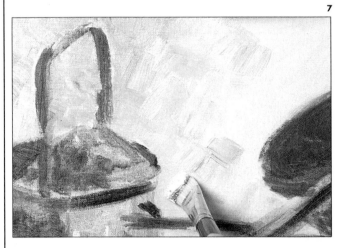

8
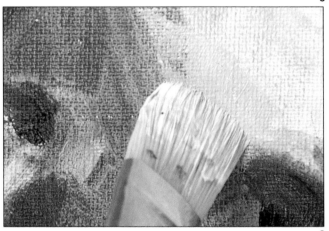

9
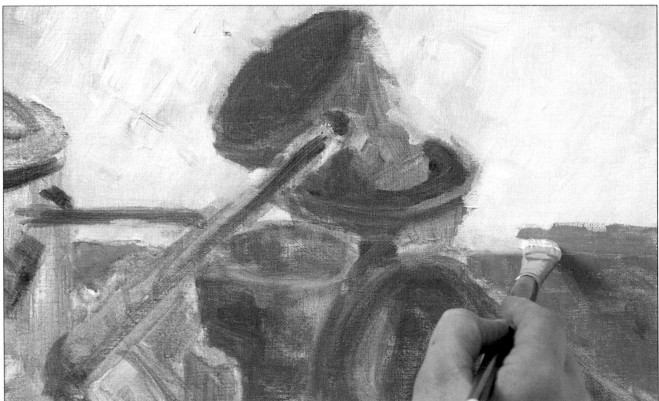

10 The tiles are now painted, as in the picture they form a background for the objects; that is, the watering can and box containing pots are in front of the tiles. Once again the artist works well up to and over the edges. For the tiles she uses a mixture of cadmium red light, burnt sienna and a touch of ultramarine blue. Keep your brushes in water when not in use.

11 While the paint is still slightly damp the artist uses the pointed handle of a brush to scratch some lights back into the paint to indicate the edge of a few of the tiles. Using paraphernalia other than brushes to make marks on a painting is not cheating as some will have you believe; all that matters is the end result and that you are happy with it.

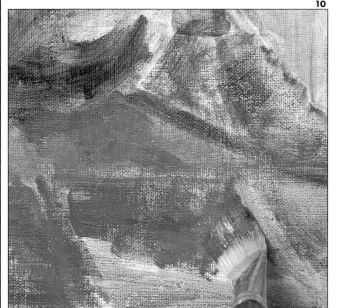
10

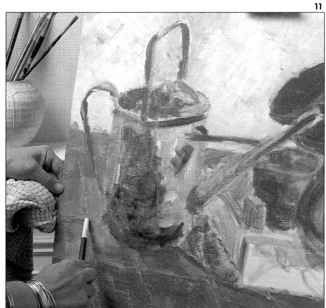
11

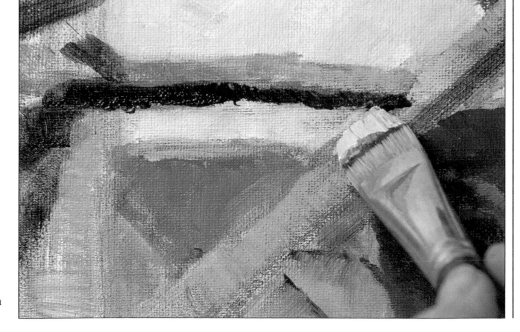
12

12 The artist now returns to the objects, having completed the background. Burnt sienna is applied with a No. 12 brush to parts of the watering can to indicate rust. Darks are strengthened where necessary and highlights are added to the handle, the spout and drum. A little ultramarine blue and burnt sienna added to a lot of white is the mixture for the highlights on the can.

13 Edges are sharpened; where the background overlapped the objects is now repainted. One long stroke of the brush, a No. 10 flat, will suffice for narrow parts such as the spout and handle. Highlights are added in the same way.

14 The artist now paints the flowerpots, strengthening the darks if needed, straightening up the edges and adding highlights. These are made by mixing cadmium red, burnt sienna (a little of each) plus titanium white.

15 Continuing with the flowerpots, detail is added. A crack is put into the foreground to add a little character to the painting. Details of flowerpot lips are put in and the shadows separating one pot from another are given attention.

16 The artist has once again scraped away some paint to indicate the edge of a tile; she feel that this shadow being in the centre of the painting needed breaking up with a touch of light. This time the paint has to be scraped out with a knife as it is completely dry.

17 The wooden fruitbox is painted – raw sienna with a touch of violet (ultramarine blue plus carmine) for the darker areas, raw sienna and titanium white for the light areas and the back of the torn paper. A little shadow is applied on the box behind the torn paper to really make it stand away. The detail is painted with a No. 2 flat brush, the letters added using cadmium red.

17

18 The painting is complete. The artist steps back to take a long scrutinizing look, checking to see if anything is not quite right. The wonderful thing about acrylic is that at this point small corrections are very easily made. Still-life subjects are all around you, nothing is unworthy of being drawn or painted. A little time spent drawing familiar objects each day will help tremendously when it comes to putting it down in paint. By following the steps of this painting almost anything around you is paintable.

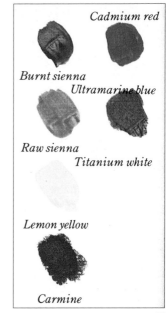

Cadmium red

Burnt sienna

Ultramarine blue

Raw sienna

Titanium white

Lemon yellow

Carmine

18

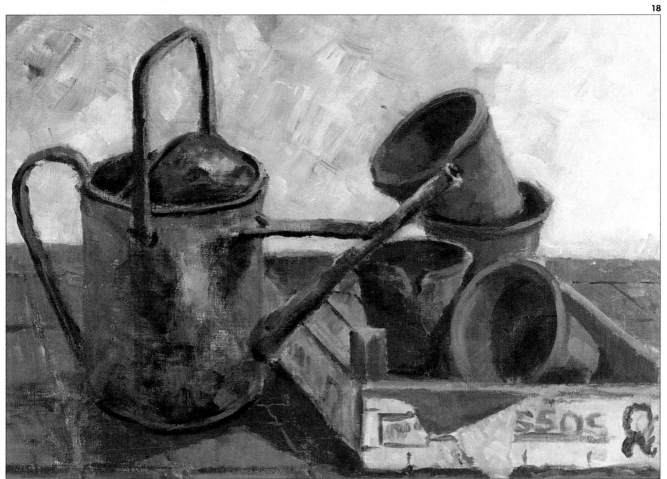

Seascape
EXPLORING ACRYLICS

How often have you sat on a beach enjoying the view only wishing that you could paint it? Here the artist demonstrates how, using acrylic paint, you can do so. This medium is ideal for painting out of doors; it can be applied with virtually any brush, large or small, on any size support. Even quite large paintings can be produced in a comparatively short period of time; this is important, as any painter who has battled with the elements will tell you. Conditions may look fine as you set out on your painting trip but weather conditions change.

In this painting the artist composes a picture using three main elements: the large shape of the sky, the land mass and the sea. Using large brushes and attacking the problem boldly, paying little attention to any particular technique she demonstrates how even the most inexperienced artist can produce a work of art. Each section of the canvas is painted directly, no underpainting first. The sky is painted very quickly using three values, light, middle and dark, and while still wet all are carefully blended together. Great depth is achieved by layering the cliffs, making colours stronger as they approach the foreground.

The only detail to the rocks is in the foreground; distant ones are painted flat. It is the uneven brushstrokes that give the impression of detail. A large brush used in a relaxed way will produce a fairly competent painting without too much frustration.

Materials: Canvas board 16 in × 20 in (40 cm × 50 cm); brushes – Nos. 10 and 12 bristle brushes, No. 3 watercolour brush, 1 in (25 mm) blender brush (a household paintbrush can be used instead); disposable palette; water atomizer – to keep paints moist on palette; 3 large jars of water; rags or paper towel.

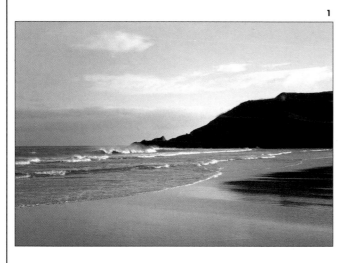

1 A typical photograph taken by many of us when on holiday at the seaside. The artist has decided to elaborate on this subject, adding more cliffs in the distance and detail into the foreground cliffs and beach. You will find that the more you paint the easier it is to add to your paintings or take away objects not required. If you feel that your imagination doesn't run to this yet, there is no harm in taking ideas from several photographs (preferably ones that you have taken yourself so that you have a feel for your subject) and putting them together in one painting.

2 The drawing is made with a No. 10 brush using ultramarine blue greatly diluted with water. The support (canvas board) is simply divided up into three main shapes: the sky, the sea and the land. Make sure that no two shapes are of similar size and shape, and check that the horizon line does not cut your support in half.

3 First, the artist applies the blue of the sky, working fairly thickly and direct, no underpainting. She thinks about the shapes of the clouds and the kind of sky she wishes to paint. Here she makes it more windswept than the photograph. The blue patches of sky are a mixture of Rembrandt blue, ultramarine blue and white. After this has been applied, dark areas for the base of the clouds are added, using the same mixture of blues and adding burnt sienna. The dark at the base of the clouds is actually a reflection of what is below: land, sea etc. Work fairly quickly so that the sky colours do not dry before you have them all on the canvas.

4 Pure titanium white is added to the bare patches of canvas board and, while the whole sky area is still fairly damp, a clean, dry 1 in (25 mm) or 1½ in (38 mm) blender brush is used to create a blended misty atmosphere. To do this just drag the brush back and forth across the wet paint.

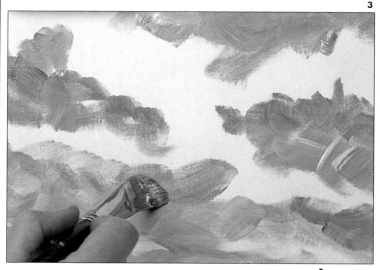

3

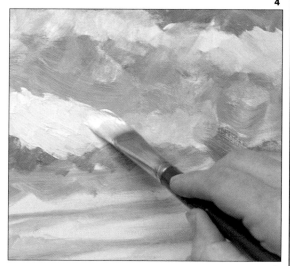

4

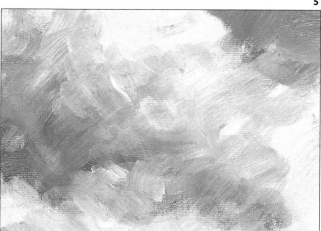

5

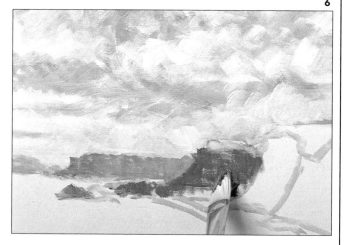

6

5 This detail shows how the clouds have been softened with the blender brush. Acrylic paints do dry fairly quickly, so to achieve this nebulous effect the artist must also work quite fast. Of course drying time depends on the atmosphere. A painting rendered outside on a misty day will take much longer to dry than one painted in a warm, centrally heated studio.

6 Working from the background to the foreground the artist paints in the cliffs. Using the same mixture that was used for the grey in the sky, but adding more white to it, the distant cliffs are painted in a flat mass. Detail cannot be seen in distant objects. As the artist moves forward to the next cliff protrusion she adds more of the blue and burnt sienna mixture to darken the grey a little. And so on to the third group of cliffs.

7 This area is still a little darker, and detail is beginning to appear. Depth is shown in a painting by strengthening and weakening colour. Distant colours are weaker, lighter; close-up ones are much stronger, darker. This effect is called aerial perspective. Detail is added to this area of cliffs in the form of grass at the top, which is a mixture of sap green and titanium white.

8 The artist, still using a mixture of ultramarine blue, Rembrandt blue and burnt sienna but this time no white, finishes painting the cliffs right up to the foreground, the right edge of the canvas board.

9 — Because the cliffs on the right are in the foreground they will not only have very dark areas in them but other values will appear. Here the artist adds some middle tones and highlights using the same grey mixture with titanium white added. Stand back and take a look. The painting is progressing wonderfully and has a great depth to it.

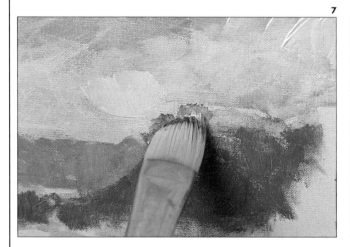

7

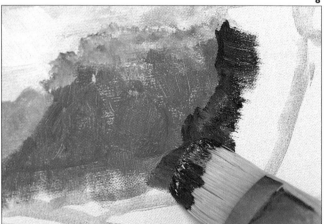

8

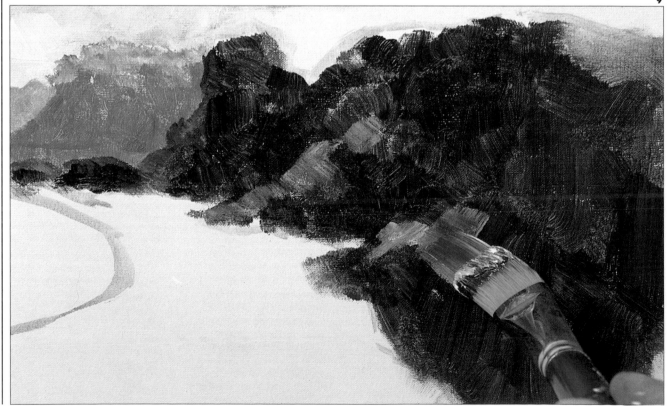

9

10 Still using a No. 12 bristle brush the artist mixes sap green with a little titanium white, keeping the mixture a little stronger than last time, and adds green to the top of the closest cliffs with a fairly free cross-hatching brushstroke.

11 With a No. 10 bristle brush and a mixture of Rembrandt blue, burnt sienna and titanium white the sea is painted in. Beginning with the mixture slightly darker for the distant sea and fairly long, smooth brushstrokes, the artist works towards the beach area. She leaves a little white space at the base of two small rocks which were added while painting the foreground cliffs.

12 As the sea gets closer the brushstrokes become shorter and spaces are left to paint in the white surf. Contrary to the rules of aerial perspective (colours fading as they recede) the sea often looks darker in the distance. Possibly this is because of the great density of volume and colour of the water.

10

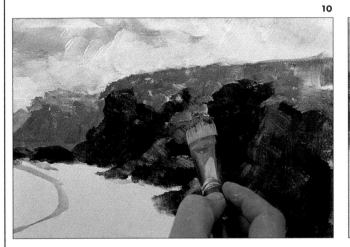

11

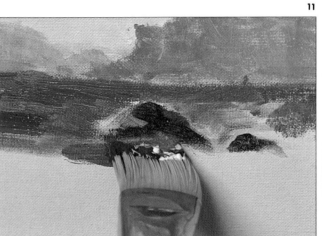

12

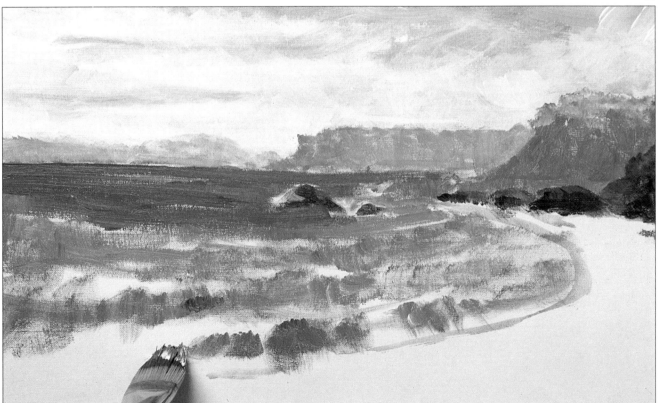

13

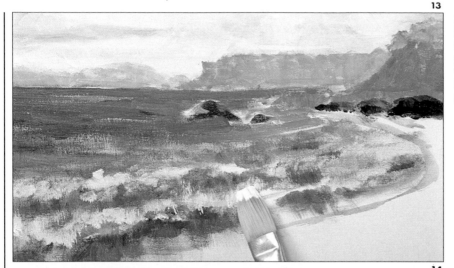

13 While the paint of the sea is still wet the artist adds titanium white, fairly thickly in places. In the distant sea a little white paint is scumbled (dragged) over the dry blue surface with a very dry brush.

14

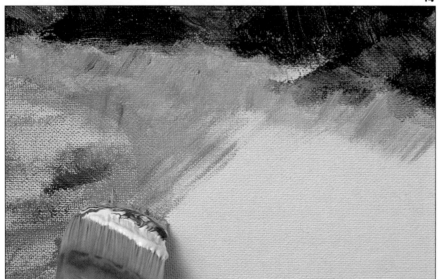

14 After having a cup of tea and allowing the painting to dry (with acrylic this will only take from ten to thirty minutes depending on the thickness of the paint) the artist paints the beach. The mixture is burnt sienna with a tiny touch of ultramarine blue to which titanium white is added to produce the right colour. The colour will get stronger as it comes towards the foreground. The paint for the beach is dragged thinly over the edge of the sea to give the illusion of the water lapping on the beach.

15

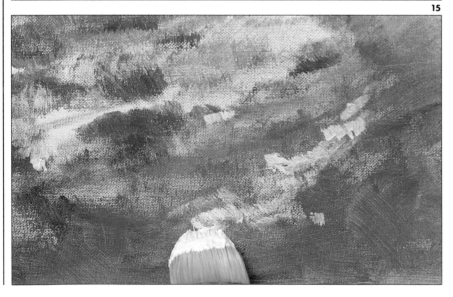

15 A little titanium white is dragged into the beach area to indicate the surf running up on to the beach. The paint is applied very carefully and sparingly as too much white will ruin the effect. If the artist feels that she has overdone this area, the paint can be quickly removed with a damp rag.

16 Extra detail is added to the foreground beach with the help of a sponge (see page 137). Using the sponge in this painting gives the illusion of pebbles or shells on the beach and on the rocks it gives the appearance of holes or barnacles. Dip the sponge into different colour mixtures that have been used throughout the painting. Begin with darks: ultramarine blue plus burnt sienna; and then light: Rembrandt blue plus white.

Don't forget to wash out the sponge after each colour has been applied or use another piece of sponge.

The artist makes a very watery mixture of ultramarine blue and burnt sienna. Using a No. 3 watercolour brush she makes little motifs to represent seagulls.

16

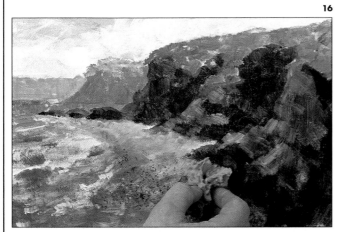

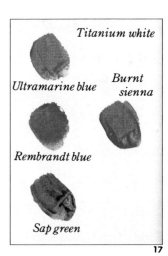

Titanium white

Ultramarine blue

Burnt sienna

Rembrandt blue

Sap green

17

17 To complete the painting, a glaze (a thin covering of paint, see page 114) is laid across the foreground rocks. This adds warmth to the area and brings it forward. This picture could just as easily have been painted on location providing the weather permitted, as it was fairly direct without too many details and stages. It actually took the artist only an hour and a half.

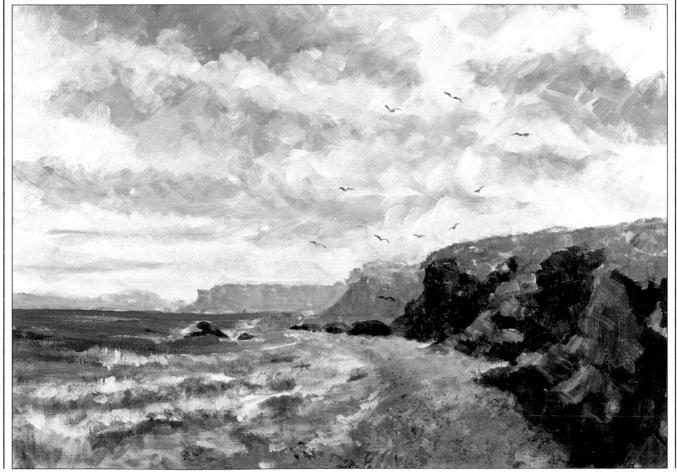

Boater and Blazer

EXPLORING ACRYLICS

This still life was set by the artist to demonstrate the techniques of painting folds both straight and angular. Draped fabric is very often avoided by the inexperienced artist who feels that it is too complicated. Painting folds can be likened to landscape painting, a subject which even the most unskilled artist may attempt.

Rolling hills bear a resemblance to soft folds, while mountains are similar to sharp-edged folds. Observation is the only secret. When attempting to paint a picture which you feel to be difficult, time spent making observational sketches is invaluable. A trick to use when painting folds is to look with half-closed eyes, which breaks the areas into flat values of dark, mid-tone and light. A painting is made up of flat shapes on a flat surface, two dimensional, and learning to paint is actually retraining one's eyes to see the world in a series of flat areas of colour.

In this painting the artist has chosen to take a closer view of the still life. She has moved right in and the subject is touching the peripheral edges of the support. If the back of the jacket was not touching the left edge of the canvas while the rest of the image was going off the bottom and right-hand side of the support, then to the viewer the objects of the painting would appear to be slipping off the right-hand corner. It is quite important to anchor the image on to at least three edges or none at all.

There are as many ways to compose a picture as there are artists. Try different approaches for yourself. Spend time with a sketchbook trying different ideas before you begin to paint. Any subject can make a dynamic painting in the hands of a competent artist. Think about your subject as you sketch, what shape of support would best suit it. Think about the negative spaces (the space around the actual objects) – they should be as interesting as the subject itself. Try to get strong tonal value; it is the contrast of lights and darks that make this painting work so well.

Materials: Canvas paper 16 in × 12 in (40 cm × 30 cm); brushes – Nos. 2, 4 and 6 flat synthetic, Nos. 10 and 12 flat bristle; disposable palette; water sprayer to keep paints moist; 3 large jars of water; rags or paper towels.

1

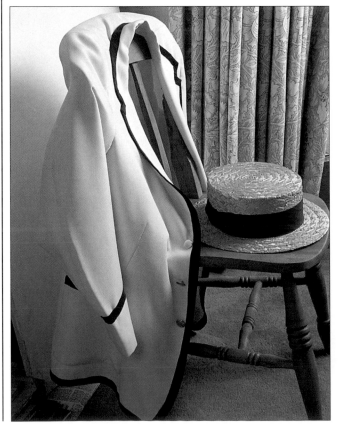

1 The still life is set up in a corner of the artist's studio. A strong light coming in to the picture from the right-hand side helps to dramatize the folds. Light-coloured fabric tends to emphasize the folds more than a darker colour. Here we have a mixture of straight folds – the drape of the curtains in the background – and angular and curved folds in the blazer.

2

2 With a No. 6 flat synthetic brush the artist draws in the subject, using a very thin mixture of raw sienna and water. The composition is a close-up 'zoomed in' view of the subject. If you decide to arrange your painting in this way be sure that the subject goes off your support (canvas paper) on at least three sides. In this way the subject will be well anchored to the surface and will not appear to be sliding off on one side, carrying the viewer's eye out of the picture.

3 Mixing cadmium red with Rembrandt blue and using a No. 10 bristle brush, the artist paints in the background. All brushstrokes are diagonal, from top right to bottom left. Darks are painted into the inner folds of the curtains using the same colours. Still allowing the drawing to show through, Rembrandt blue and burnt sienna are mixed and applied in the shadow areas of the blazer. Talens yellow is the underpainting colour for the hat and raw sienna for the chair. Darks are added to the hat and chair using the same mixture as the darks in the blazer. The artist remembers at all times to keep her used brushes in a jar of water and intermittently sprays the paint squeezed out on the palette.

4 At this point the artist steps back to view the painting's progress. This is a very important exercise and it should be repeated many times throughout the painting's evolution. Here she sees that the background is too dark and does not allow a strong enough contrast with the darks of the blazer, so mixing cadmium red with Rembrandt blue and adding titanium white she repaints the background, all the time using diagonal brushstrokes. A painting developed in this technique, with the brushstrokes all going the same way, tends to produce a static uniformity to the picture which lends itself perfectly to this subject.

3
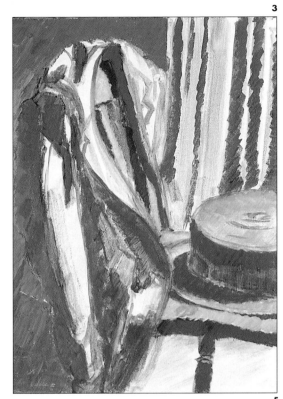

4
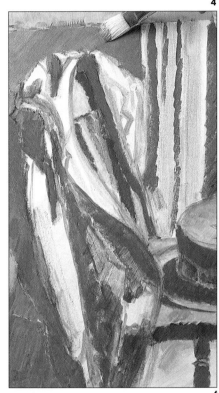

5
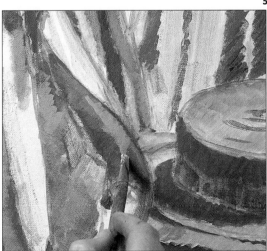

6
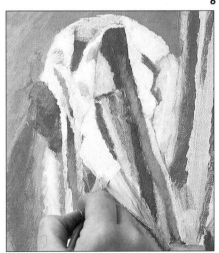

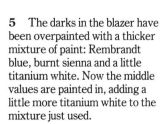

5 The darks in the blazer have been overpainted with a thicker mixture of paint: Rembrandt blue, burnt sienna and a little titanium white. Now the middle values are painted in, adding a little more titanium white to the mixture just used.

6 Titanium white with a very little Talens yellow added to it is used for the lightest areas of the blazer. Adding yellow or orange to white makes the white area look brighter; it gives a warmth to white. The artist observes the folds of the jacket very carefully; touches of light placed prudently introduce life to the painting.

7 With a strong mixture of Rembrandt blue and cadmium red (so strong that the colour looks almost black) the artist paints in the ribbon on the blazer. For this she uses a No. 4 flat synthetic brush.

8 Details of seams are added in the lapels, shoulders, down the sleeve and the dart in the jacket body. This is done by dipping the edge of a large flat brush, No. 12, into a mixture of ultramarine and burnt sienna and carefully placing the marks with the tip of the bristles.

9 The artist has added a little highlight in places along the seams using the same method with the large flat brush, only this time using the mixture of titanium white with a touch of Talens yellow. The buttons are now painted, first placing in the darks and finishing with a light touch for the shiny highlight of the chrome buttons.

10 Paying close attention to the changes in tone the artist paints the curtains. Mixing Rembrandt blue with a little each of Talens yellow and cadmium red she strengthens the darks and adds any which were not observed earlier. Then the middle value is added, mixing a little titanium white with the dark mixture. Finally, the lightest value is painted in, this time adding a lot of white.

7
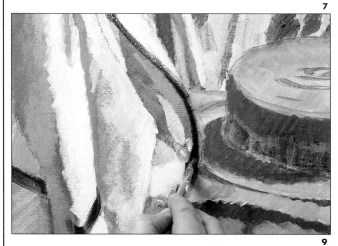

8
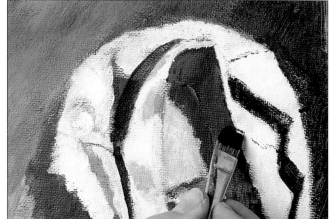

9
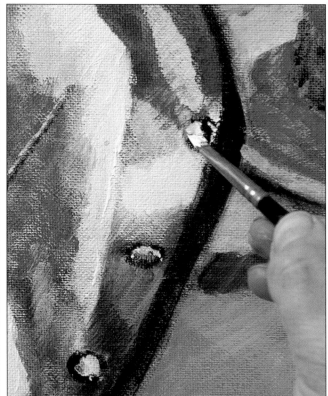

10
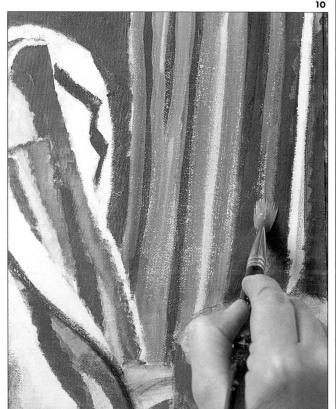

11 All that is left now to complete the painting is the boater and chair. The artist makes a mixture of Talens yellow, cadmium red and a little Rembrandt blue for the dark sides. Then, using the same mixture but omitting the blue and adding more titanium white, she paints the crown and the lighter areas of the brim, scumbling lightly over the darks, allowing them to show through.

The dark edges of the chair are painted with raw sienna, Rembrandt blue and a touch of cadmium red, the light seat and back with raw sienna and titanium white.

12 The final touches are added: shadows behind the buttons, the ribbon around the hat. For these the artist uses the dark mixture of Rembrandt blue and cadmium red light. Adding titanium white to this she finishes the floor area under the chair. What a striking painting a simple subject makes.

11

12

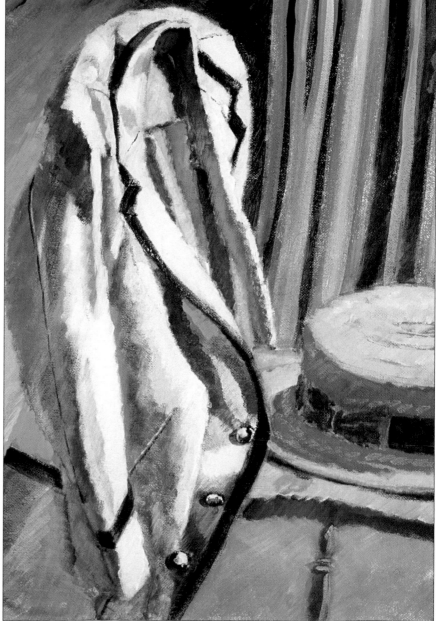

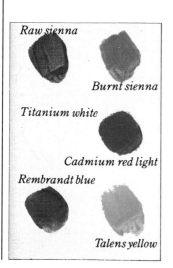

Raw sienna

Burnt sienna

Titanium white

Cadmium red light

Rembrandt blue

Talens yellow

French Street
EXPLORING ACRYLICS

While on a painting trip to France the artist was inspired by this row of very old farm houses with beautiful cobbled courtyards, ivy-covered walls and a backdrop of wooded hills. An area such as this will provide the artist with hours, days, even weeks of work, and it is not necessary to spend a lot of time searching for subject matter. The houses in this street all face into their individual courtyards with only the ends visible as we look along; this provides the artist with a perfect subject for a painting based on perspective.

The artist spends quite a measurable amount of time sketching as well as painting while on location, as this provides her with a store of optical images as well as producing sketchbooks which are a source of reference for the future.

Materials: tracing paper; 2B pencil; kneadable eraser; conté crayon; ballpoint pen; canvas 16 in × 12 in (40 cm × 30 cm); spray fixative; disposable palette; water atomizer, to keep paints damp on palette; 3 large jars of water; rags or paper towels; acrylic gel medium.

Quick sketches of complicated details such as chimney pots, gates, parts of boats etc. take away the guesswork when finishing or painting pictures in the studio.

By using a cool blue, cerulean throughout this painting, the artist has implied a sunny by cool atmosphere. The colours used are mostly delicate, contrast being provided by the strong foreground shadows created by the early springtime sunshine.

1 The artist spent many hours in this street, not only painting but collecting information for further work back in the studio. Many sketches were made of the nooks and crannies, backyards and children as well as photographs taken. This photograph provides a good prospect for a painting based on linear and aerial perspective, the houses and street appearing to diminish in the distance both in size and colour. The houses in this street are quite different as they all face into their individual courtyards, leaving only the ends apparent on the street. This provides a simple scene for the artist to paint, the linear perspective being uncomplicated.

2 The subject is first drawn, using a set square and 2B pencil on to tracing paper (see the second drawing in perspective on page 49). When the artist is satisfied with the drawing, she goes over the lines at the back of the paper with conté crayon and then, using a ballpoint pen, transfers it to the canvas. NB a ballpoint pen is used in the first instance to enable the artist to see which of the pencil lines she has transferred without going over them twice, and in the second, it provides a sharper line than using a coloured pencil.

1

2

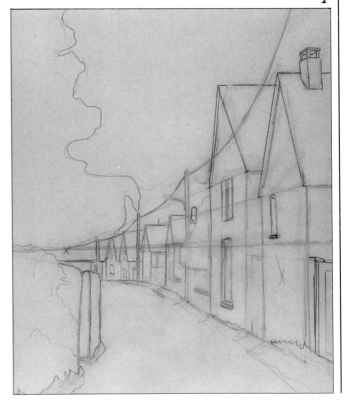

3 After spraying the transferred conté drawing with fixative (hairspray can be used) a tonal painting was made using a No. 10 brush and burnt umber paint. For areas of detail, a No. 4 brush was used.

4 Using cerulean blue and a little burnt umber, mixed with acrylic gel medium, the darks in the sky are painted. Working quickly, not giving the dark sky areas time to dry, titanium white is added to this sky colour and blended in.

5 Using the side of the little finger in a circular motion, the sky is blended. More white is added in places and blended in this same way. The finger can be a very useful tool when painting, especially for areas of sky.

6 Working from the background to the foreground, the artist uses a No. 4 flat brush with cerulean blue, burnt sienna, a little titanium white, mixed with gel medium to put in the distant trees. First the mass is painted and then, using the tip of the flat brush, the trunks are added using burnt umber.

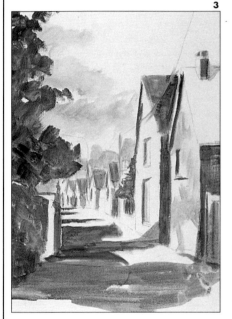
3

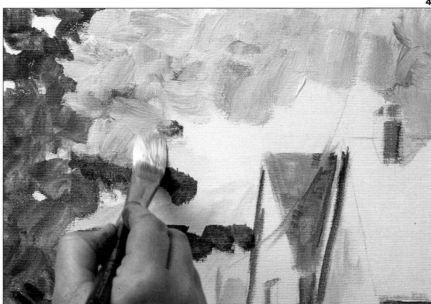
4

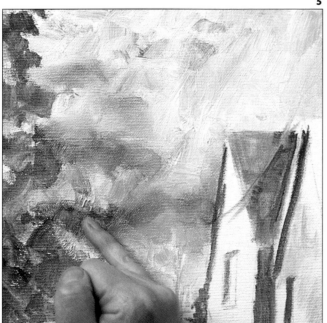
5

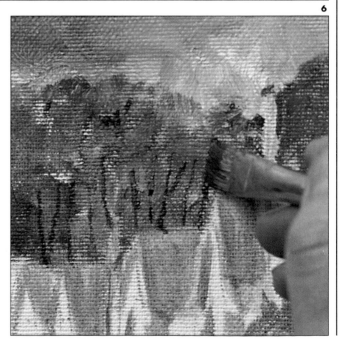
6

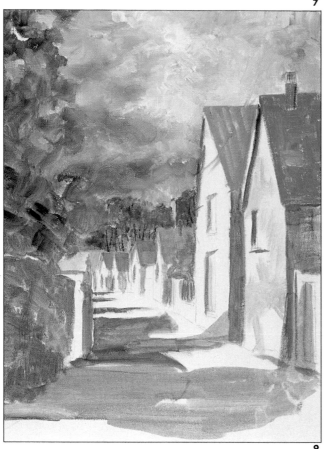

7

8

7 The artist, working from the left side of the painting to the right, paints in the rooftops. For this she uses cadmium red and cerulean blue, adding titanium white for the distant houses. The paint is mixed with the gel painting medium (this stretches the paint, diluting the colour, but does not thin the paint) and applied, allowing the burnt umber underpainting to show through in places. For the light brown roof raw sienna is mixed with cerulean blue and titanium white.

8 With burnt sienna, a little cerulean blue and a small amount of titanium white, the darks are re-established in the houses, keeping the darkest paint mixture for the foreground houses. A little of this same mixture is used to indicate the shadow on the wall by each window, under the window ledges and under the eaves of the overhanging roofs. Following this step, the artist paints the sunny side of the houses using titanium white and raw sienna. For the pink foreground house, she uses raw sienna, cadmium red and titanium white. A little of this mixture is lightly scumbled over the shadow side of the foreground house to provide an impression of detail.

9

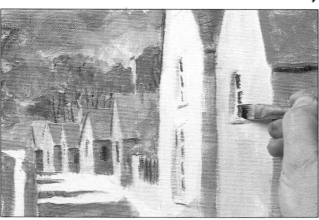

10

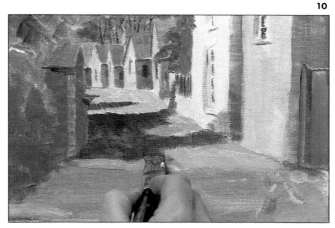

9 Burnt umber, applied with a No. 4 brush, is used to paint in small dark shapes for the inset windows. At this stage all other dark detail is introduced, adding a little titanium white to the umber as it is applied to distant buildings. The fence on the right is added using the same mixture.

10 After painting the foreground gate with cerulean blue, burnt sienna and white, the artist paints the road. This time she uses burnt umber and cerulean blue in the dark areas; raw sienna with a touch of cerulean blue and titanium white in the light ones. Sap green is now mixed with a small amount of titanium white and the artist paints in the short stubble of early spring grass at the base of the buildings.

11 Telegraph poles are added and also the vines, remembering that they will not be taut but will sag in the middle. Using the same brush, a No. 4 flat and burnt sienna, the artist also indicates the wintering creeper on the pink house.

12 The foreground of this painting is not only the road but the tree and wall on the left. To complete this painting, the artist painted this area loosely, without much detail. The subject of the painting is the row of houses. By adding minutiae to the tree and wall in the shape of leaves, bricks etc. the eye would be carried away from its topic completely. The artist has kept all detail away from the edges of her painting except for the right side, where the gate leads the eye down the row of houses and the street to the focal point of the painting.

11

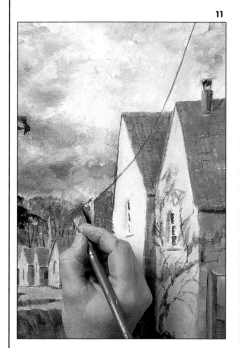

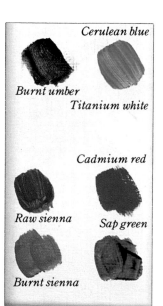

Cerulean blue

Burnt umber

Titanium white

Cadmium red

Raw sienna

Sap green

Burnt sienna

12

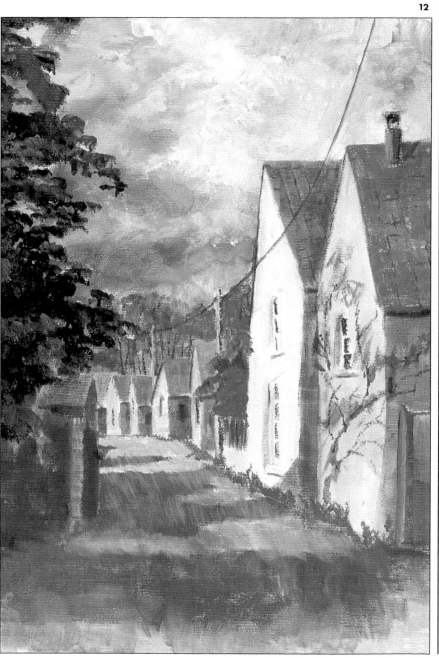

Chapter 6
Watercolour Techniques

In this chapter we demonstrate how acrylic paint can be used to do just about everything that traditional watercolour can do and a great deal more. Painting with watercolours can be an exasperating experience for the beginner, but using the same techniques with acrylics can eliminate many of the headaches.

Before embarking on the painting of a complete picture the painter is advised to spend some time practising with the materials: learning to lay washes, flat and graded, mixing colours and experimenting with different types of supports. This is especially important when using acrylics like watercolours as the pigment will soak quite quickly into the paper and will become virtually impossible to remove or correct. Learning to paint is very exciting, but it doesn't happen overnight. One needs patience and time to practise; fifteen minutes spent every day painting a sky or drawing a cup and saucer – it doesn't matter what you draw or paint – will very quickly add up and in a relatively short while you will discover that your work is improving and that you are enjoying it more and more. A little time spent frequently is a hundred times more effective than a longer time, say two hours, but only once a week.

And so to start a painting. Whether practising with the medium first or going straight in, it is quite important to prepare a fairly accurate drawing to begin with. The first washes are laid and left to dry – this is where using acrylics has an advantage as once this first wash has completely dried nothing will remove it, so subsequent washes can be painted quite freely without fear of disturbing the first layer or lifting it. Because each successive touch of the brush doesn't dissolve the underlying tone, every stroke retains its precise shape and colour. Several layers can be applied without producing muddy tones.

When using the traditional water medium, one is normally advised to work from light to dark as it is almost impossible to apply light paint over dark. In acrylics this is not so; a lighter colour can be applied in a semi-transparent wash over a dark area and still retain its transparency. However it is advisable to begin the painting by working light to dark.

Many people find it virtually impossible to tell the difference between a painting executed in traditional watercolours and one painted using similar techniques only in acrylic paint.

Techniques

WET IN WET

'Wet in wet' is a watercolour technique which can be employed by the acrylic artist with great satisfaction. The paper can be completely soaked in a sink or bath or small areas can be wetted with a brush. It takes time to recognize when the paper is ready to receive the paint. If the paper is too wet, the paint will just disperse everywhere, completely out of control. If the paper is too dry, the paint will not move at all, but just form a hard edge. The secret is to wait until the shine has just disappeared on the surface; some of the water has evaporated and the paper has absorbed the rest. At first, it means staying fairly close and keeping an eye on it. Going off to make a cup of coffee while the paper reaches its required state is fatal; all too often you will find that is has passed the right stage and is too dry.

If you wish lightly to draw in your subject, this should be done before the paper is wetted.

Once the paper is ready – still quite damp – apply the paint to the desired areas. You will find that it slowly runs and is quite controllable, effecting soft edges. With acrylics, once the first wash has been applied and is thoroughly dry, the paper can be completely rewetted to apply the next and subsequent layers. Details can be added finally when the paper is dry.

1 For this demonstration, the artist used unprimed hardboard for the support. Using a No. 12 large bristle brush and lemon yellow mixed to a very fluid consistency with water, she very freely applied the drawing.

2 Drawing in this way, lines can be pulled or large areas blocked in to describe the object.

Acrylic paint works wonderfully well in watercolour techniques and for the beginner it is easier than the traditional medium as once it is laid and dry no amount of overworking will disturb it or muddy the colours.

The traditional technique as used for hundreds of years by many well-known artists is the building up of values in the form of flat washes, working from light to dark, allowing each wash to dry completely before adding the following one. No white paint is used; the white of the paper is saved or used for pastel tints.

A great master of this technique was John Sell Cotman 1782–1842, a member of the Norwich school. His work is well worth studying. His paintings have a clean, fresh crispness about them; they are linear patterns of flat smooth shapes.

The following demonstration shows how this technique is applied, and whether it is a plant pot that you are painting or some other object, a field, a house or a person, the same principles apply.

1

2

1 After the plant pot is lightly sketched, the artist applies a thin wash of paint, omitting areas (saving the white paper) in areas of highlight or shine. The colours used are a mixture of burnt sienna and cadmium red thinned down with water.

2 The light source coming from the right, the artist paints in the second value over the original wash which is completely dry.

3

4

3 The third and darkest value is added. Note that neither the darkest dark nor the lightest light are at the edges. To do this would flatten out the round object.

4 Final details are added with the colour mixed a little stronger than the strongest value in the object – under the pot, in the cracks and under the rim. This technique can be applied to all subjects.

USING WHITE SPACE

When using acrylics as a watercolour medium, we apply the same rules, and the most important is not to use white paint. The white of the paper furnishes the light areas. To make a colour lighter, thin it down with water; when applied to white paper it will appear as a light shade.

1 When painting a dark area behind a light or white area, it is advisable first to sketch in the areas to be saved and to paint carefully around these areas. In this demonstration, only the trunks and main branches have been kept white. Further along in the painting, the artist would darken parts of these areas and save space to represent snow blown against the trees or the white birch of the silver birch. It is advisable to plan the picture carefully when intending to save white areas, as once it has been painted over, even if removed immediately, it is impossible to regain the crisp whiteness of the paper.

2 It is recommended to use it with quite liquid, very wet paint. To achieve the knobbly effect of branches, push the brush with the tip of the bristles slightly bent. Flicking it will create grasses and reeds and by pulling it you will be able to create long lines such as telegraph wires, clothes lines and rigging. To make a line that goes from thick to thin press down on the brush and as you move along the line, gradually lift off and lessen the pressure until you have a fine line.

3 The toothbrush is a useful adjunct to the artist for adding texture and atmosphere. Here, loaded with white paint, the thumb is drawn across the bristles causing the paint to splatter on to the painting, giving the illusion of snow. Used with dark paint on tree trunks, old wooden boards and rocks, it gives the illusion of tiny holes. Different colours, such as ultramarine blue and orange splattered individually on to a road, gravel path or beach can produce interesting textures.

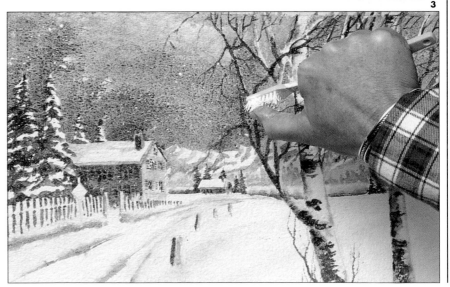

MASKING

Masking fluid is a rubber solution which can be applied to paper to save white areas. It is especially useful for minute areas such as seagulls in a strong blue sky or flying in front of dark cliffs, for blossoms on a dark green tree or tiny highlights on a shiny surface. To apply it, use an old paintbrush or a pen. It is a good idea to keep one brush especially for this project. If the bristles of the brush are rubbed on to hand soap before use, the masking fluid will wash out easily.

1 Masking fluid should never be used in the sun as the sunlight changes its properties and it becomes very sticky and virtually impossible to remove. Also it should not be left on the paper for weeks and weeks as this too will make it difficult to remove.

2 After the masking fluid has completely dried, you can apply your paint over it; either one wash or several, it won't make any difference.

3 The painting finished and absolutely dry, the masking fluid can be removed. To do this, lightly rub your clean fingers over the areas where the fluid is applied and it will just roll off as stretchy little bits of rubber. Another way to remove it is with a putty eraser.

Old Car

WATERCOLOUR TECHNIQUES

This old car has stood for many years waiting patiently to be restored, resting silently on its bed of ever-changing foliage. Whatever the season, it stirs the imagination of the artist. The ruggedness of the old metal and the sharp edges are complemented by the softness of the rolling sky, the misty distance and the roundness of the little blue car in the background.

Painting with a limited palette of only four colours, the artist used acrylic paint in the traditional watercolour technique of laying one wash on top of another, each consecutive layer being darker than the one before. Using acrylic in this way is perhaps easier than using the traditional medium. An initial wash over with watercolour can be tricky. If the artist passes the brush over the same area several times, the underpainting (first wash) will lift and mix with the current colour. With acrylic this is not possible, as once the paint has dried it is permanent. Of course nothing is perfect; the one drawback is that the acrylic acts as a size paper sealant, and the second wash is not absorbed by the paper but lies on the top. It must be added, though, that only the most trained eye will be able to ascertain if the work is rendered in the traditional medium of watercolour or acrylic.

In this painting, the artist has created her own sky to complement the diagonal line of the car. Painting skies is exciting and the artist can be very imaginative, creating a sky that will dramatize the subject. The painting was built up from background to foreground, soft layers of flat washes providing a mysterious backdrop for the historic cars.

Masking fluid is used sparingly by the artist to save small areas of white paper. It can be a wonderful adjunct to the painter when used correctly, but too much of it will ruin a painting. The fluid should only be used for small areas where it is fiddly to go around each little area with the brush. It is very useful for saving highlights on shiny metal and glass, as is used in this example. Using the masking fluid in large areas could prove to be quite disastrous; the surface of the paper can be damaged and it can produce hard mechanical edges. It was also found to be useful for the foreground of this painting for the light foliage growing in front of the dark undercarriage of the car. It would have been very difficult to paint around each leaf, and the finished painting would have appeared to be much busier at the bottom, therefore taking the eye down and away from the subject.

1 This old car, a Rover, belonging to the artist's brother who for years has threatened to restore it, has been the inspiration for several paintings. From this angle, it provides a dramatic subject, proud and majestic on its throne of weeds. The rounded and not quite so old Austin in the background provides the artist with a subtle contrast.

Materials: Waterford HP 140 lb (300 g) watercolour paper 15 in × 11 in (37.5 cm × 27.5 cm); 2B pencil; putty eraser; brush – No. 20 synthetic watercolour brush; disposable palette; water sprayer to keep paints moist; 3 jars of water; paper towel; masking fluid.

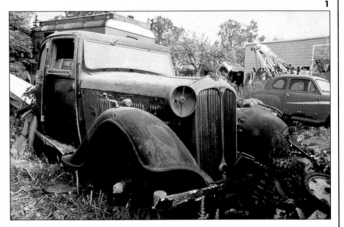

2 Using a piece of Waterford 140 lb (300 g) watercolour paper, the artist sketches out the image lightly with a 2B pencil. If a mistake is made, she uses a putty eraser to remove it, this being more sympathetic to the paper than an ordinary eraser. It is of the utmost importance not to damage the surface of the paper as it will not receive the paint smoothly. After the drawing is complete, masking fluid is applied to all areas of the cars which the artist wishes to remain white, highlights etc. and left to dry. She also applies masking fluid where lighter weeds will be in the foreground. For this, she uses a very old watercolour brush. Masking tape (1 in 2.5 cm wide) is then used on the edge of the paper to create a white border and to stiffen the support (paper) a little.

3 Drawing completed and the masking fluid dry, the artist begins to paint. Using a very large watercolour brush, a No. 20, and lots of water, the artist applies a mixture of ultramarine blue and burnt sienna to the dry paper, leaving areas for the shape of the clouds. With a very clean wet brush, she softens some of the edges. Clouds are like everything else that we see; they diminish in size and colour as they disappear into the distance, a fact often overlooked by those beginning to paint.

4 Working in this traditional watercolour technique, each area painted must be allowed to dry before the next is applied. If you lightly rest the back of your fingers on the area believed to be dry and it feels cool to the touch, this means that it is not dry, and therefore you must wait a little longer. Many artists, when using watercolour or acrylic in a watercolour technique, paint two or even three pictures at a time so as not to waste time. A hair dryer used on a low temperature can be used when painting indoors.

With the sky already dry, the artist now adds the distant landscape, using a very thin mixture of sap green and ultramarine blue to form a soft grey green, painting the area flat as no detail will be seen in the distance. Note that white is completely omitted from the palette of this painting.

5 With the colour slightly strengthened, a middle distance is added to the whole width of the painting, carefully carrying the paint around the two cars and also through the windows of the Austin.

6 The artist has darkened the green by adding burnt sienna to the mixture. She introduces this as shadows into the middle ground foliage. This will have two effects: it will show from which angle the light source is coming into the picture and, by introducing a second value to an area, it will bring that part forward, so pushing the previous wash back and creating the illusion of distance.

3

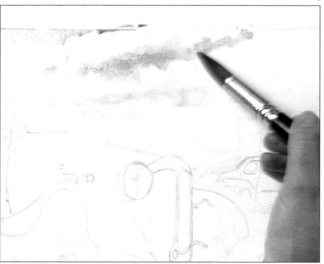

4

5

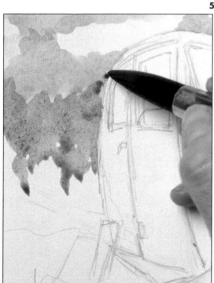

6

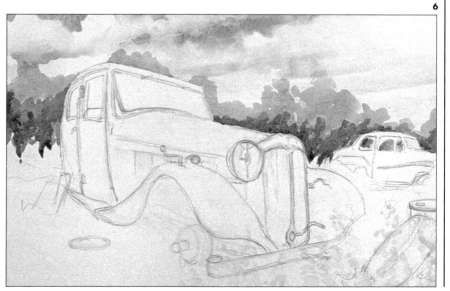

7 The artist has applied the first value of blue to the lightest areas of colour of the small car. This was applied all over, covering the masking fluid too, by using the No. 20 brush and a very watered down ultramarine blue. The same colour is then quickly applied to the Rover.

8 While it is still quite damp, the brush is washed out and a little burnt sienna, thinly mixed with water, is applied to the areas of rust. This technique is called wet into wet (see page 72).

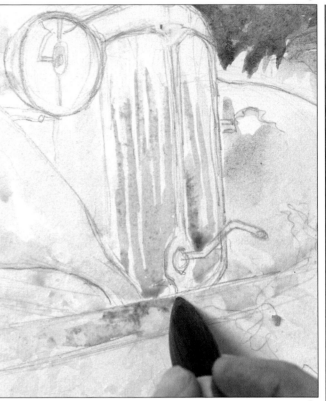

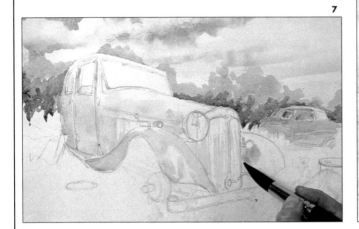

9 The painting is becoming quite exciting, and waiting for areas to dry can be frustrating when the artist is keen to progress. But to keep the painting looking fresh, this is a necessity.

With a stronger mix of ultramarine blue and burnt sienna, she adds a second value to the cars, being careful all the time to leave the white areas.

10 Air vents are painted in using the tip of the No. 20 brush. When buying a new watercolour brush it is important to choose one with a good point. This can be checked by dipping the brush into a glass of water, provided by the shop, before you make your purchase.

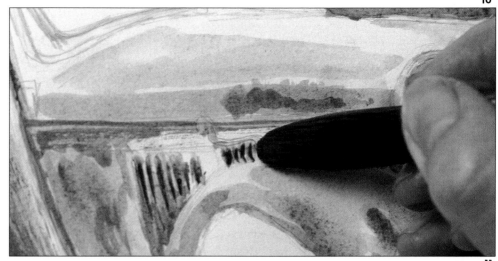

11 Using the same mixture that was used for the air vents, ultramarine blue and burnt sienna, but not so much water added this time, the artist darkens the area under the mudguards.

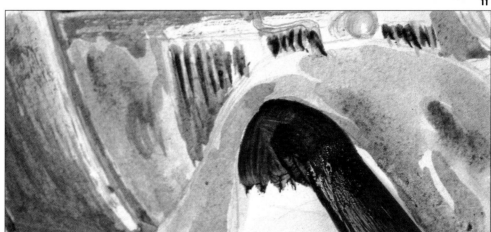

12 The rest of the third value darks are added inside the Austin, underneath it, inside the Rover and underneath, in the radiator, on the offside mudguard and the spare tyre lying in the weeds. The artist now steps back to admire her work: is the background strong enough or too weak, has enough white been left, does the contrast, so far, in the cars describe the form? Being satisfied she progresses.

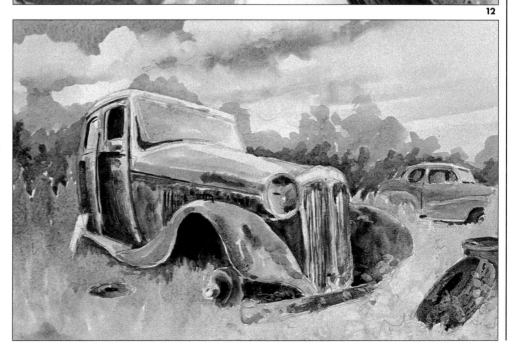

13

13 A flat wash of sap green and lemon yellow is applied all over the foreground, including the areas of masking fluid. When this has dried a mid-tone is added, leaving parts of the light area to shine through, eventually giving a darker value. Burnt sienna is dropped in while the green is still wet to provide contrast – red (burnt sienna) is complementary to green.

14 When all areas are totally dry, not at all cool to the touch, the hand of the artist is gently rubbed across the painting to remove all traces of the masking fluid, leaving clean white areas.

14

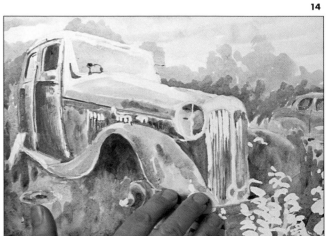

15

15 The artist mixes lemon yellow with sap green to produce a fresh light green with which to paint the foreground weeds. When it is dry she strengthens the colour and adds some detail to the plants.

16 With observation, the artist notes that a strong dark is needed behind the foreground plants and beneath the car. Without this the car seems to be floating on a bed of green fluff. For the darks she again uses sap green and ultramarine blue, but this time adds a small amount of burnt sienna. At this point the painting is again checked for any missing detail, and this is corrected.

17 The masking tape is now carefully removed, keeping the hand close to the painting and pulling away (not up, as this will tear away the surface of the paper, sometimes taking bites from the sides of the actual painting).

18 What a delightful painting this subject has made and how fresh the work looks. For anyone not used to applying actual watercolour, acrylic will be much simpler to employ as each wash, after it dries, cannot be lifted by the subsequent wash, thus dismissing any worry of colours becoming muddy.

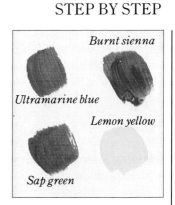

Burnt sienna

Ultramarine blue

Lemon yellow

Sap green

16

17

18

Anemones

WATERCOLOUR TECHNIQUES

Here the artist uses acrylics in the watercolour technique of wet into wet painting. She chooses a beautiful bunch of brightly coloured anemones for her subject, offset by an antique lace cloth and a preserves jar. She feels that there is more character in a jar than a formal vase.

Painting wet into wet is fascinating technique and actually means that wet paint is applied to wet paper. The degree of wetness on the paper from flooded shiny wet to dull and damp will affect the control of the paint. Wet paint applied to very wet paper will run uncontrollably, whereas drier paint put on to only damp paper will hardly move, so you have all of these degrees of wetness to explore. Perhaps it would be a good idea to practise before you apply the technique to a painting.

The anemones were chosen for this demonstration because they seem to lend themselves to the technique

employed; the soft edges of the petals and leaves almost appear without effort. Many accidents will happen when painting wet into wet; the secret is to recognize them and use them. Often the paint will run away with itself and before your very eyes wonderful things will happen – unexpected tones and textures appear, beautiful shapes, just perfect for the area. When things go wrong do not be in too much of a hurry to correct them; learn when to leave things alone, when to accentuate the mistake or even build a picture around it. To the artist's amused annoyance, very often the one area of your painting that is most admired by everyone is the 'happy accident', and you have not had a hand in the matter at all.

1 For this wet into wet demonstration, anemones were chosen for their bright translucent colours with fresh green contrast of stalks and leaves. The artist chose to put them into an old preserves jar in preference to a vase, liking the less formal image and the view of the stalks through the glass. The white lace-edged cloth was added to complete the composition.

Materials: Cotman 140 lb (300·g) watercolour paper 16 in × 17 in (40 cm × 42.5 cm); brushes – 1 in (25 mm) wash, Nos. 20 and No. 4 watercolour

brushes; 2B pencil; putty eraser; disposable palette; water atomizer; rags or paper towels; 3 jars of clean water.

2 Using a piece of Cotman 140 lb (300 g) watercolour paper, the artist lightly sketches with a 2B pencil, paying particular attention to the shape of the jar and the lettering. The positions of the flowers are only indicated with a very light circle. The drawing completed, the artist wets the paper with a 1 in (25 mm) wash brush, not allowing the water to go over the areas of jar and table; this will allow some hard edges to form around these sections.

3 While waiting for the shine to disappear from the paper, indicating that the water has been absorbed but the paper is still wet, the artist mixes the paint for the blooms. Carmine and cadmium red are used for the red flowers, carmine alone for the pink, and carmine and ultramarine blue for the violet ones. When the paper has reached its right degree of dampness, the paint is gently touched to the paper in the right spots with a No. 20 watercolour brush; slowly it disperses into a soft flower petal. All the flower heads are painted in this way.

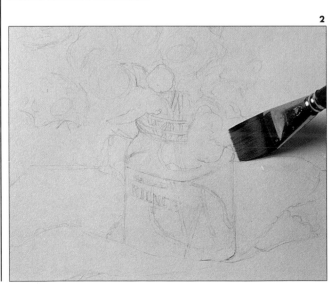

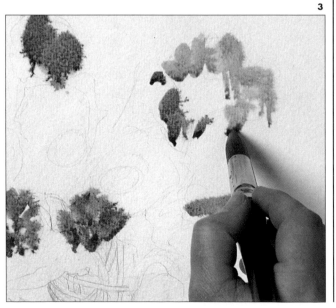

4 It is necessary to work quite quickly while the paper is still damp, but if the paper dries, small areas can be rewetted with clean water or the whole painting can be allowed to dry, thus making the paint permanent, and then the whole sheet can be wetted again. Here leaves are added to the wet paper using a mixture of lemon yellow and ultramarine blue.

5 With the paper still damp, a mixture of ultramarine blue, burnt sienna and carmine is applied with the No. 20 brush to the centre of the anemones. It is very important to keep the water used for mixing the colour clean. Change it often to retain the freshness in the painting.

6 The artist now adds some petal detail to the painting using a dark shade of colour to separate them in places. Parts of the paper will still be damp and parts completely dry; this does not matter as it will give the artist the contrast of some soft edges and some hard. If the painter is not too sure how the colour will appear when applied, she finds it helpful to try it out on a piece of scrap paper.

7 The stalks of the flowers in the jar have been painted with a little lemon yellow mixed with sap green. Where they are tinged with brown, burnt sienna is lightly touched in while the green is still damp. Note how the refraction of the water alters the direction of the stalks. To indicate water in the jar, the artist observes and paints the shapes of the reflected colours, noting that some of these shapes are rather dark.

4
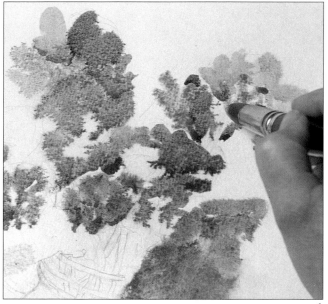

5
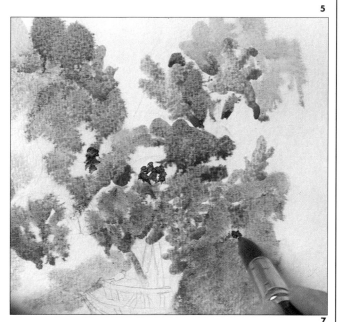

6

7

8 Before adding some darkened detail to the leaves with a No. 20 watercolour brush, the artist changes to a No. 4 brush and works a little on the neck of the jar.

9 The background area is dampened again and a watery mixture of ultramarine blue and burnt sienna is flooded in, stronger behind the cloth to emphasize its whiteness. The background colour is graded upwards, the colour almost disappearing as it reaches the tops of the flowers.

10 With a No. 4 brush, the lettering of the trademark is carefully added to the jar. The complete letter is not necessary, just enough marks to give the impression that the word 'kilner' is completely written.

11 The artist observes the shape of shadows and folds in the white tablecloth and paints them in with a soft grey colour made from ultramarine blue and burnt sienna. (See folds on pages 62-65.)

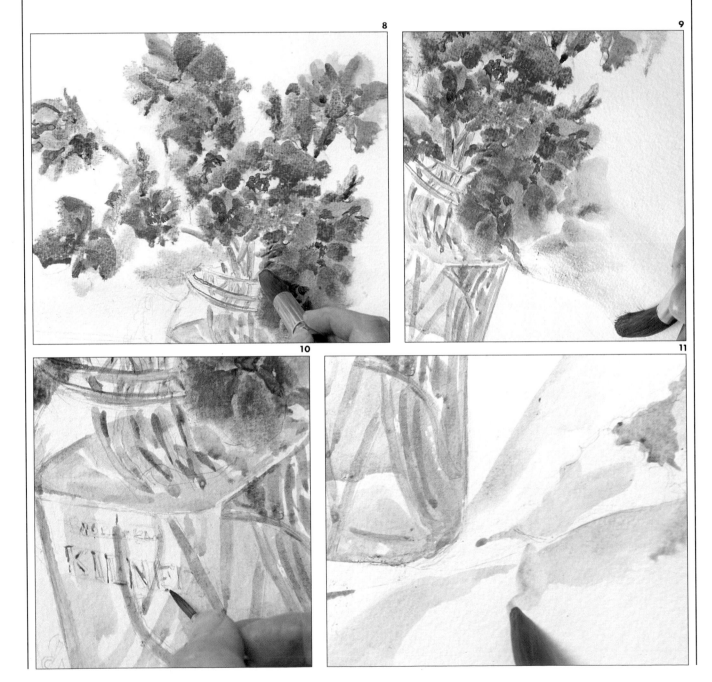

12 Finishing touches are added to the painting. The holes of the lace are added with a stronger mixture of the grey used for the folds in step 11. The table top is painted with the same two colours, but using more of the burnt sienna. A shadow is added on the table beneath the folds of the cloth.

12

13 An interesting feature of the finished painting is that it touches and overlaps all edges of the support. Very often paintings portraying vases of flowers have the image placed in the centre with a great deal of negative space surrounding it. Using the space positively and filling it as the artist has here tends to produce a more pleasing image.

13

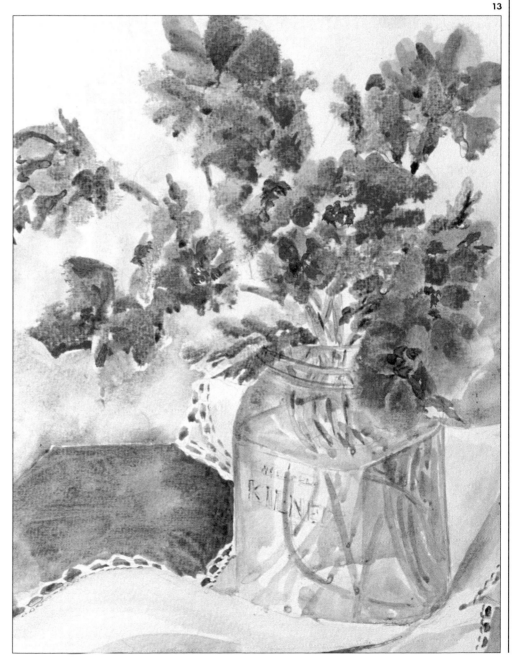

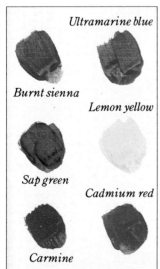

Ultramarine blue

Burnt sienna

Lemon yellow

Sap green

Cadmium red

Carmine

Snow Scene
WATERCOLOUR TECHNIQUES

Setting yourself the task of creating a painting from several sources can be exciting. Here the artist uses two photographs taken in summer and trees from her 'memory bank' to produce a stunning snow scene. The finished product seems to bear no resemblance to its source material but is a creation of the painter.

Photographs should not be copied detail for detail but just used as a take-off point. When developing a picture from several sources, it is advisable to work your ideas out in a sketchbook or on a scrap of paper. This will save a lot of rubbing out and damage to the surface of the watercolour paper. In this painting, the artist has limited her palette to only two colours, ultramarine blue and burnt sienna. From these two colours, she has achieved many hues, tones and values. These two colours, when mixed together, produce a grainy effect which is complementary to this subject. A very rough paper has been used which also adds to the result of the finished picture. When developing a painting, take care to think about the materials you will use and the effects they will produce.

No white paint at all is used in the actual painting of this scene; it was used only in the last instance smeared onto a toothbrush and flicked over the painting to produce the impression of snow over the darker areas. The white sections of the painting, even the picket fence are all the paper 'saved'.

1 The painting was inspired by the artist's love of winter in the Alps. These two

photographs, which she used for reference, were taken by her when she lived in Oberammergau in Germany. The foreground trees were added from her memory bank. If you feel that you have not had enough experience in drawing and painting to do this, it is quite permissible to add objects from any source – encyclopedias, magazines, books, or preferably your own sketches made on location.

Materials: Very rough Aquarelle watercolour paper 140 lb (300 g), size 12 in × 19 in (30 cm × 47.5 cm); brushes – No. 20 watercolour, No. 1 watercolour rigger; 2B pencil; putty eraser, masking tape 1 in (25 mm) wide; rags and tissues; disposable palette; 3 jars clean water; water atomizer; toothbrush.

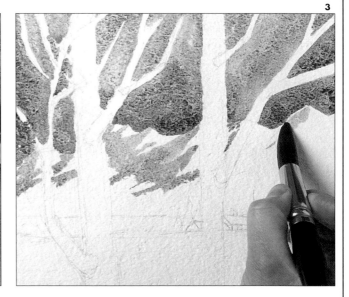

2 Working on a very rough watercolour paper, the artist plans out and sketches her composition. Before she begins to paint, she adds masking tape to the edges of her paper to give it a crisp finish when removed and to give extra strength to the paper while she works.

A mixture of ultramarine blue and burnt sienna, rather dark, is applied to the already wetted paper. This was accomplished with a No. 20 watercolour brush, omitting the trunks and main branches of the trees and only bringing it down to the tops of the mountains, keeping a crisp edge.

3 After allowing the area of the sky to dry thoroughly, the shadow side of the mountains is painted in. Once the light source has been established, it must remain the same throughout the painting.

4 Before the paint on the mountains is allowed to dry, it must be weakened with water and washed down to the edge of the distant field.

5 A dark line of paint is taken across the whole width of the painting, omitting trees and houses, just at the top of the foreground snowfield. While it is still wet, the brush is thoroughly washed out; the top edge of the paint is then carefully softened with the clean wet brush, while the bottom edge is left hard, which gives the impression of a dip in the terrain.

6 Using the point of the No. 20 brush and a light mixture of the grey, fir trees are added in clumps coming down the lower slopes of the foothills. The colours are kept lighter in the background, becoming stronger as they approach the foreground.

7 The artist, continuing to develop the painting, makes a stronger mixture of ultramarine blue and burnt sienna and paints in the fir trees around the houses in the distance, being very careful to keep the snowy roof tops crisp around the edges.

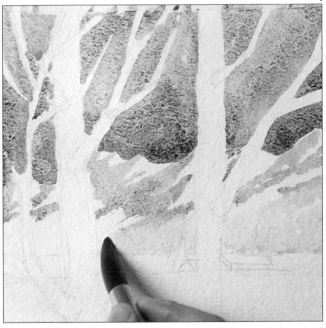

4

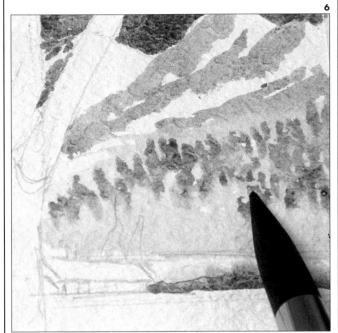

6

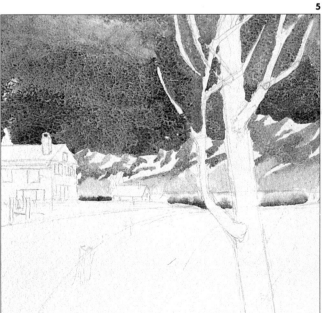

5

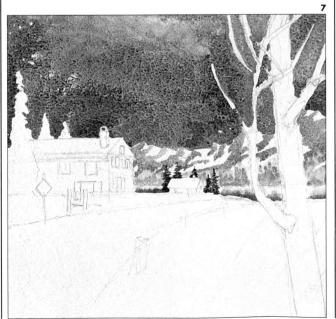

7

8 A weak solution of burnt sienna is painted over all the houses, including the chimney pots. When this is dry, a darker paint is added, using the burnt sienna with a touch of ultramarine blue to darken it. This is applied to the left, darker side of the walls and chimney pots, under the eaves and along the shadowy edges of the windows.

9 Using the two colours strongly this time, the artist puts in the dark interiors of the houses as seen through the windows. A common mistake of amateur artists is to paint dark frames around the windows and to leave the glass light. Windows are normally only light when viewed from inside looking out. Using the same mixture, a little dark detail is added under the eaves in the foreground house.

10 The thickness of the snow is indicated on the roofs by applying a line of watered-down ultramarine blue. A little of this colour is also dragged across the snowy roof to suggest shadows from the pine trees.

11 With a strong mixture, the artist paints in the foreground firs, being careful to save areas of white paper signifying fallen snow on the heavy branches.

8

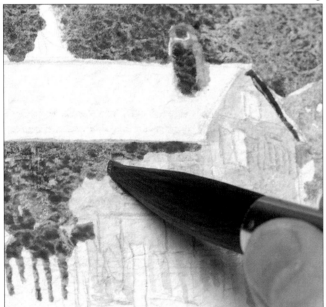

10

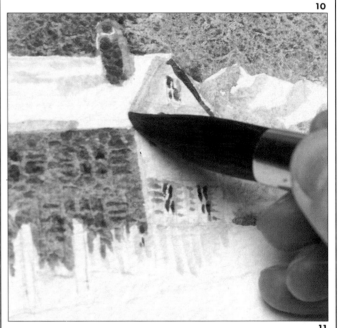

9

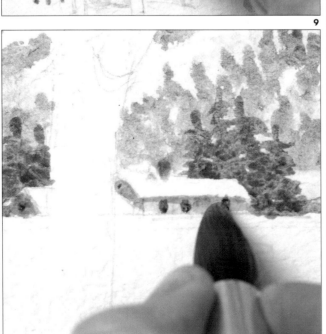

11

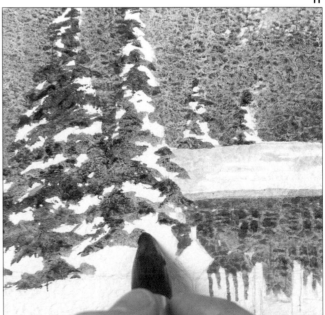

12

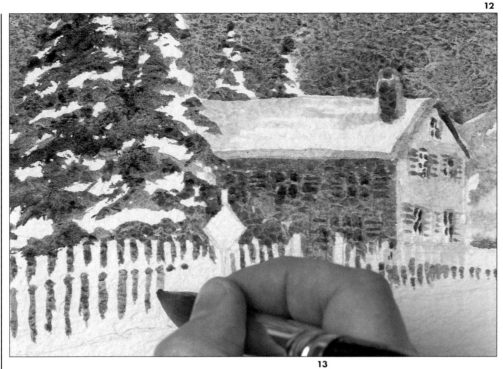

12 The artist then paints carefully around the street sign and the picket fence. No masking fluid and no white paint are used in this painting at all.

13 The last touches are added to the distant scene before the trees are painted in. Ultramarine blue and burnt sienna are mixed to a medium strength, and lines are painted on the road where a car has passed through the freshly fallen snow. The brush is then quickly washed out and one edge of ruts is softened. Following this, a little of the blue is well watered down and boldly swept across the foreground snow field.

13

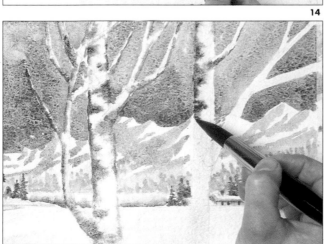

14 The white paper left for the silver birch trees is now wetted and, after the shine has gone, a dark grey mixture is applied in small areas of the trunks and main branches, and to the posts along the edge of the street. When this is dry, the dark eyes of the silver birches and the dark of the marker posts are painted on.

15 Using a No. 1 rigger brush, the artist paints in the middle size branches of the trees. To make broader branches, she presses down on to the brush and for lighter ones, she uses less pressure.

15

14

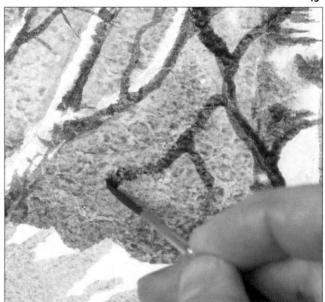

16 The only time that the artist uses white paint is to spatter snow on to the painting. To do this, she puts the white paint into a saucer or old bottle lid, keeping it clear of the other colours. Using a wet hard toothbrush and holding the painting in a vertical position so not to drop large splodges of white on to it, she flicks the paint off the toothbrush on to the painting, giving the impression of snow falling.

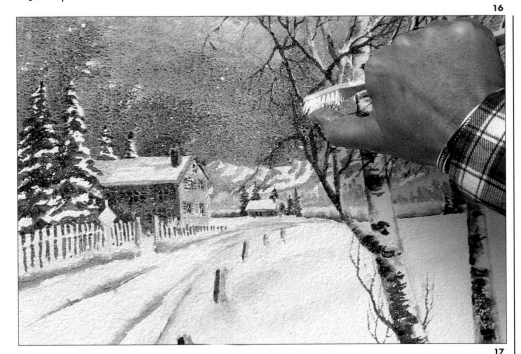

17 This is a close-up detail of the painting, a picture in its own right. Here you can see quite clearly the fine branches painted with the No. 1 rigger brush and also the spots of white snow flicked on with the toothbrush.

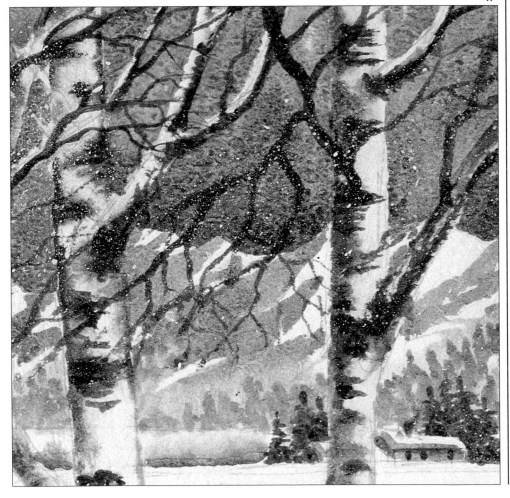

18 The finished painting with the masking tape removed to reveal a clean crisp edge to the picture. A seemingly complicated subject has been handled simply with a very limited palette – only two colours. The artist, using her imagination, has developed a delightful painting from two unlikely photographs and a little creativity.

Ultramarine blue

Burnt sienna

18

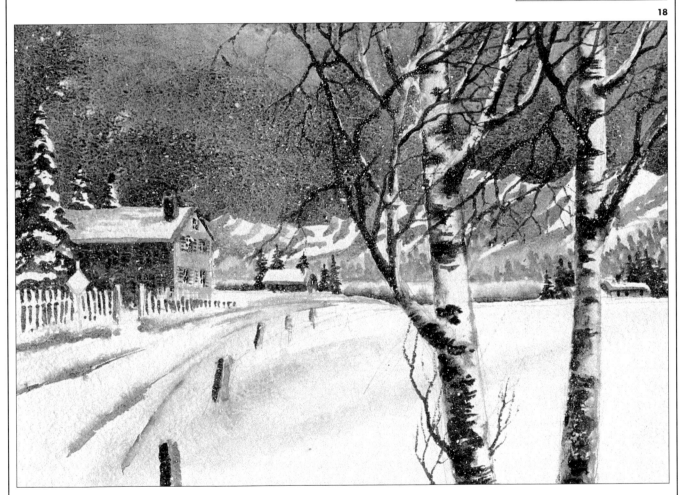

Chapter 7
Oil Techniques

The painter can continually learn from his fellow artists, both contemporary and former. Painting should be a life-long learning experience, with the artist evolving in a natural way. Those who continue to paint the same way over and over because they are 'good at it', turn their art into a craft – a repetition of techniques to produce a finished object. Try to keep an open mind, go to as many exhibitions as you possibly can, not just to look at the kind of work that you prefer but to look at the different and unconventional too. If this is not possible, the next best place is your local library. There you will find art books on all periods, very often describing the techniques, palette etc., of the individual artist. Trying to assimilate other artists, perhaps not actually copying the original picture but using similar subject matter and techniques, can be very satisfying and will open up your imagination to other things that you will want to try.

This chapter demonstrates using acrylic in oil techniques. In the first instance the artist employs techniques used by Van Gogh and also steals his subject matter to produce a painting in the modern medium, acrylic. I am sure if Van Gogh had been alive today, he would have experimented with acrylics and possibly produced some of his great works with them. The accelerated drying time of this medium would have surely lent itself to his work. In the second demonstration, the artist uses another technique borrowed from the Post-Impressionist era, pointillism. This is a process in which dots of unmixed colour are juxtaposed on a white ground so that from a distance they fuse in the viewer's eye into appropriate intermediate tones. This technique is especially helpful to beginners as it is quite controlled and colours are used from the tube undiluted and unmixed. By laying one colour against and over another the painter quickly learns the possible effects of the individual colours.

The last painting in this chapter, a self–portrait, demonstrates how, with the use of a retarder to slow the drying time of the acrylic medium, the paint can be blended in a manner similar to manipulating oil paint; this is particularly useful when painting flesh tones. It is very often impossible to discern if a picture has been painted in oil or acrylic, especially if the finished product has been varnished or a gloss medium has been used throughout the painting. Pure acrylics dry to a matt finish, but contemporary oil painters often varnish their finished work with a matt varnish, so it can become very confusing.

DRAWING WITH THE BRUSH

Drawing is an essential part of painting. It has been said that painting is just drawing with the brush. Drawing is form without colour.

Drawing with the brush allows the artist more freedom of expression. Using charcoal or a pencil means sacrificing the fluidity and sweep that can be attained with the brush and a liquid medium.

When preparing to do a painting, the student may often get carried away by laborious detail only to have wasted time by losing all that he has painstakingly drawn when the underpainting is applied.

Any colour can be used to execute the drawing as most of it will be lost in the painting, but it makes sense to use a colour that will blend in with the painting. If the lines you have drawn are wrong, instead of trying to wipe them out, just change the colour on the brush, remembering which colour is the correct drawing.

Employing this technique of going straight on to the bare support with a brush is especially enjoyable when tackling work on a large scale.

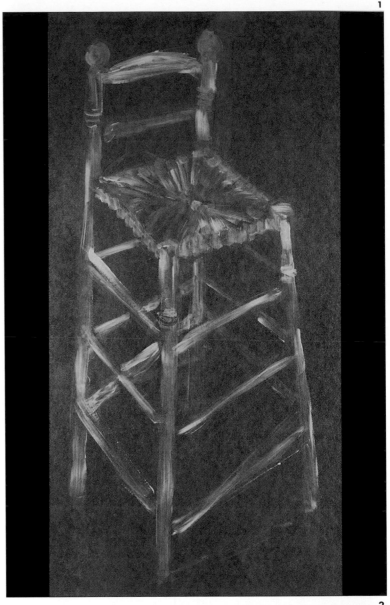

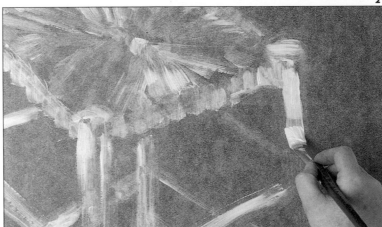

1 Using a large brush and lemon yellow paint the artist quickly sketches in the chair.

2 Mistakes can easily be corrected as the painting develops.

STIPPLING

Stippling a technique whereby paint is applied in little dabs instead of actual brushstrokes. Following the rules of Seurat, the nineteenth century Post-Impressionist, the paint is used pure, unmixed straight from the tube. The only mixing is with white when a paler tone is required. This improves the luminosity of the colour. For darker colours, hues that would normally be mixed on the palette are applied to the canvas individually in layer upon layer of dots until the required depth of colour is acquired.

1 Dabs of ultramarine are applied for this demonstration of stippling. Dots are applied close together where the colour requirement is strongest and further apart where the colour will be paler.

2 After allowing the first application of paint to dry, the second colour is added in much the same way. Consecutive layers are built up until the

required value is achieved.

3 The paint, Rembrandt blue, is mixed with white as a paler colour is wanted. White is a very strong opaque and applied over any other colour would completely block it out.

4 Pure burnt sienna is stippled on. As a dark tone is required here, several layers will be built up of two individual colours.

Chair with Pipe

OIL TECHNIQUES

Using a very large piece of hardboard and painting very boldly with rather large brushes, the artist shows how an old master's painting can be interpreted in acrylics. Rather than working from a reproduction of the original painting, the artist simulates the still life with her own kitchen chair standing in a sunny corner of the kitchen. A great deal can be learned by working as the old masters did; the following demonstration is just one approach. Often painters will go to galleries and museums and actually copy the original so that they can be sure of copying the colours exactly.

This artist is using entirely modern materials to simulate a Van Gogh. Unprimed hardboard is used to replace raw canvas and acrylic plaints instead of oils. She approaches the work in much the same way as Van Gogh: no drawing, straight in with a brush working direct and bold. Shapes are blocked in in their local colours with expressive brushstrokes. As the painting progresses, the drawing of the chair is strengthened with bright blue lines like Van Gogh's. Perhaps when he said, 'I study nature so as not to do foolish things . . . however, I don't mind so much whether my colour corresponds exactly, as long as it looks beautiful on my canvas', this is what he meant.

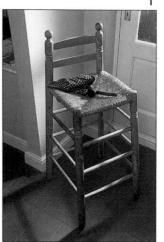

1 This rush-seated wooden chair was placed in the sunlight in the artist's kitchen. Standing on red quarry tiles, it already captures the impression of a Van Gogh painting – old pipe and spotted handkerchief lying on the seat. What a wonderful eye Van Gogh must have had to see beauty in the simplest of objects and want to make them into paintings.

Materials: Hardboard, smooth side unprimed, 24 in × 48 in (60 cm × 120 cm); brushes – Nos. 10, 12 and 16 flat bristle, Nos. 2 and 4 flat synthetic; disposable palette; rags or paper towels; 3 jars water; water atomizer.

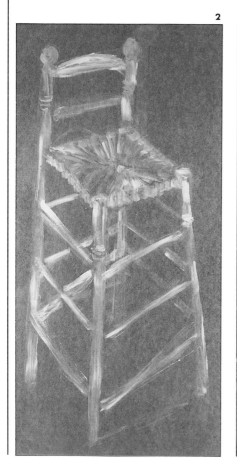

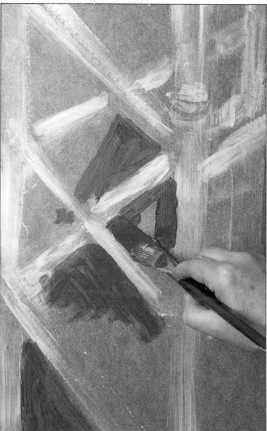

2 Where the old master used oil paint and unprimed canvas, this artist is using the more modern materials to make a facsimile of the original painting. Here she uses unprimed hardboard, with a lemon yellow acrylic paint to block in the composition loosely with a No. 10 bristle brush, without drawing first. The perspective in the drawing is not correct, but with this medium that is not a problem as it will be dry in minutes and can be painted over.

3 Using the same brush, the artist blocks in the tiles around the feet and legs of the stool. To do this, she uses a mixture of cadmium red and burnt sienna.

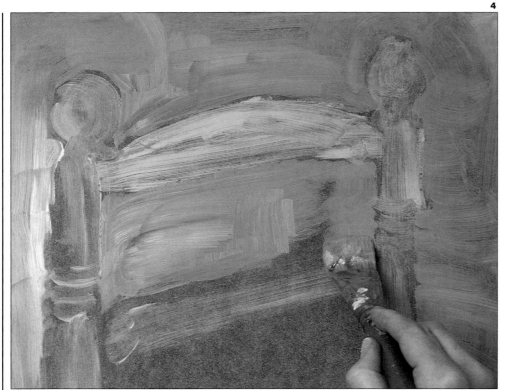

4

4 The wall is blocked in next. Because of the size of this painting, a great amount of white paint will be needed, so instead of using titanium white, the artist uses acrylic gesso primer. This works perfectly well when the artist does not require a heavy build up of paint as it is a little runnier than tube paint, and also cheaper. To the white gesso is added Rembrandt blue. The resulting light blue colour is applied to the hardboard with bold strokes with a very large, No. 16, flat bristle brush.

5

6

5 The corners of the wall and the skirting board are created by developing the values. Burnt sienna is added to the Rembrandt blue to darken the colour and worked into the areas furthest from the light. White is added to the Rembrandt blue in considerable amount to lighten it to denote the places that the sunshine catches.

6 The artist now begins to develop the darks in the chair. For this, she uses Talens yellow, burnt sienna and Rembrandt blue. Using the No. 16 brush, she paints very boldly, pulling long brushstrokes along the bars of the chair.

7 With the same brush and colour, detail is applied to the rush seat. To do this, the artist uses only the tip of the brush held at an angle.

NB It is very important to keep the brushes in water when not in use. Owing to the size of the painting, a lot of paint will be squeezed on to the palette, so keep it damp by spraying with the water atomizer.

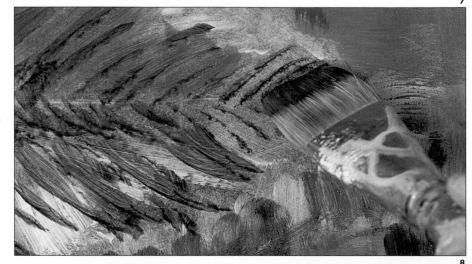

8 Highlights are applied with a No. 10 flat brush. Talens yellow mixed with white is the colour used. If you look at the subject with half-closed eyes, the highlights will be more apparent to you.

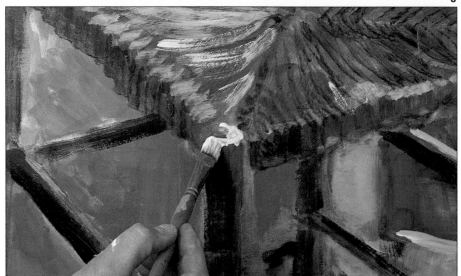

9 A blue line 'à la Van Gogh' is drawn around parts of the image, usually along the darker edges, but sometimes in the lighter areas to add contrast to the painting. The blue line recedes and so throws forward the bright yellowy orange chair. Blue is complementary to orange (see pages 30–33 on colour) and so the two will be enhanced when juxtaposed.

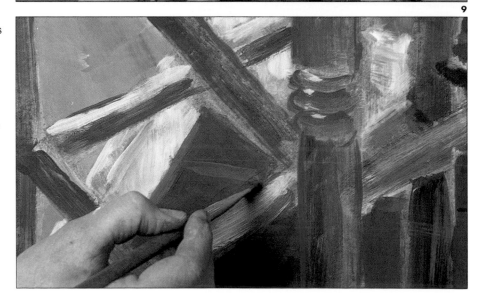

10

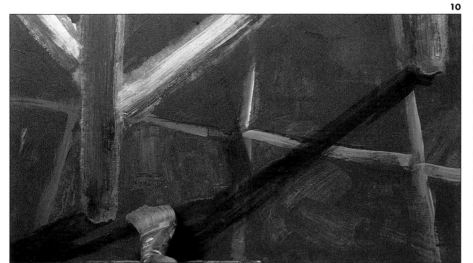

11

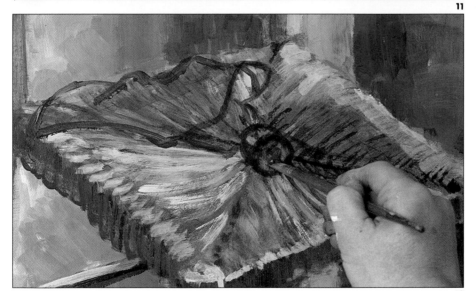

12

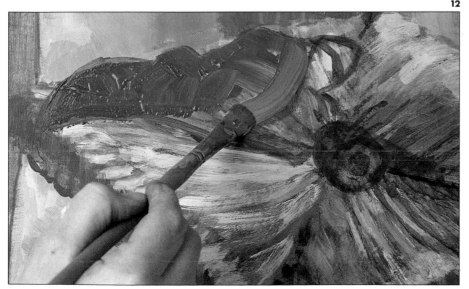

10 Rembrandt blue and Talens yellow are mixed to form a grey green which is used to draw the tiles in perspective on the floor. The mix is the right colour for the cement between each tile. The lines are drawn with a No. 6 flat brush. Each individual tile is then painted with a dark red mixture of burnt sienna, cadmium red light and a little Rembrandt blue to darken it. The artist discovered that the lines of tiles were not quite in perspective. This is not a problem with acrylic as she just overpainted the original grey green lines and minutes later reapplied them. After the tiles were established, the artist painted in the strong dark shadows using a darker mix of the floor colour. Now she paints the sun-dappled areas. Using a thin mixture of Talens yellow and cadmium red light, she gradually builds up the brightness, blending the soft edges.

11 The main part of the painting completed, the artist is able to draw in the pipe and handkerchief. Using oil paint, Van Gogh probably had to wait for weeks to do this as, according to art historians, he too added the pipe when the chair was completely dry. The outline drawing is made with a No. 4 brush, using a mix of burnt sienna and Rembrandt blue.

12 The handkerchief is blocked in with Rembrandt blue and white. The drawing is left to show through in places.

13 Using a No. 7 flat brush, the artist observes and paints in the darks of the handkerchief. She does this working in flat planes with Rembrandt blue and burnt sienna. The light areas are added in the same way; this time Rembrandt blue and white is the mix.

14 With a No. 2 brush and pure white, the dotted pattern is added. Viewers of paintings are often impressed by pattern in a picture, but in actual fact it is probably the simplest part for the painter. Not every spot need be added, just enough to trick the eye into believing that every spot is carefully rendered.

15 The pipe is painted; first the middle tones are blocked in, next the darks and finally the light rim around the top and light along the side. Various mixes of Rembrandt blue and burnt sienna were used, more blue when the colour needed to be darker, white added to make it lighter.

16 Shiny highlight is added to the pipe using white. Shadow is also applied under the pipe and handkerchief on the chair. For this, the artist used burnt sienna, Talens yellow and Rembrandt blue.

13

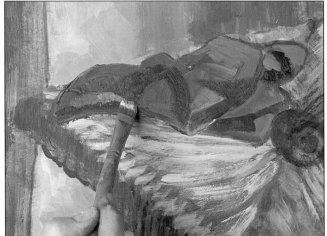

15

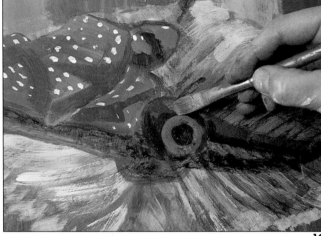

14

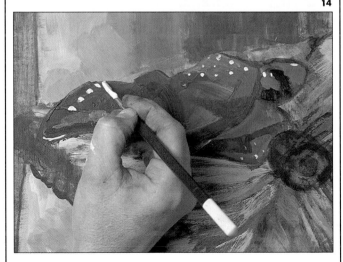

16

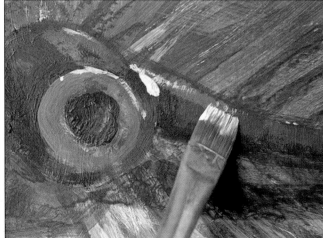

100

17 A close-up detail to show the finished handkerchief and pipe on the seat of the chair. How convincing they look; the handkerchief crumpled, just thrown there.

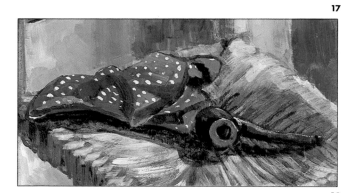

18 Van Gogh would never believe it, a large painting like this completed in a matter of hours and the paint totally dry almost as soon as the work was finished. I am sure it would have convinced him to use acrylics.

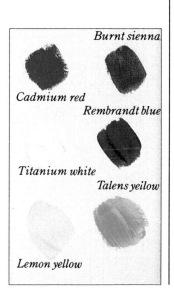

Burnt sienna

Cadmium red

Rembrandt blue

Titanium white

Talens yellow

Lemon yellow

The Two Gardeners
OIL TECHNIQUES

Towards the end of the nineteenth century, Georges Seurat developed a technique of painting which was later named 'pointillist'. Using oil paints, he worked with only pure colours (straight from the tube) to develop his method of producing pictures with only dots of colour. White, which he considered to be of no colour, was the only paint that he mixed; this was crucial to his work as he felt that it increased the reflected powers of the other colours and evoked a feeling of natural light. A drawback for Seurat was the length of time that oil paint took to dry. The build up of paint was a slow process as he worked in a wet over dry technique to retain the purity of the colours.

The painting in this section of the book is fashioned after Seurat, using his technique and working from a photograph that the artist took of two figures known throughout her life from a small village in Leicestershire.

Time should be spent establishing a good drawing from which to work. Following this, little can go wrong as the painting method is very controlled and mistakes can be caught and corrected very quickly, as this artist shows in her demonstration. The confusion of colour mixing, often a problem for the amateur painter, is avoided, as paint is used straight from the tube with no other colour additions. Although this technique is time consuming, it is well worth the effort – the end result a shimmering picture of fresh colours, a delight to even the most unartistic eye.

1 Figures unposed in action can be a problem for the artist. Working from life, all that is normally possible is a few quick sketches before the subject moves. People are animate and even when standing still are moving hands and heads and shifting their weight from one foot to another. This artist takes many photographs of people and incorporates them into her paintings when necessary.

3 Only a No.2 flat brush is used throughout the painting. The colours used are always as they come from the tube unless they are lightened. For this, the titanium white is added. Darks are made by placing a lot of colour on top of another – the colours being mixed optically on the canvas. The darks in the cap are painted by the artist, first making dots with ultramarine blue, followed by similar marks of burnt sienna. The hair is painted using the same two colours and white. The brush is not dragged in a conventional stroke but dabbed on to the canvas and removed. Now the artist applies colour for the face – first cadmium red, followed by lemon yellow, and last burnt sienna mixed with titanium white. All colours show through when finished and the eye mixes them to produce the skin tone.

Materials: Cañvas 14 in × 10 in (35 cm × 25 cm); brush – No. 2 flat synthetic; 2B pencil; eraser; disposable palette; rags; 3 jars water; water atomizer (to keep paint moist on palette).

2 The figures are drawn carefully onto the canvas with a 2B pencil, and the artist checks to see that all proportions are correct.

4 Using ultramarine blue, the artist goes over her pencil drawing with little dashes so as not to lose it. Following this, she applied burnt sienna to the jacket area.

5 Consecutive layers of ultramarine blue and burnt sienna were built up to develop the volume of the jacket with more in the darker areas. Raw sienna is used for the lighter tones and titanium white is then added to it for the very bright areas such as the shoulders.

6 The shoes are painted with the same two colours as the jacket, again the burnt sienna being the predominant colour. White areas are added last for the highlight on the side.

7 The artist finishes painting the man on the left. For his trousers, she first applies burnt sienna to the shadow areas. Over this she uses ultramarine blue for the mid-tones and then titanium white added to the blue for the light. Part of the background is now applied using a mix of cadmium red and titanium white. Because of the speed that acrylic dries, whole areas can be painted flat – for example, the brick wall in the background; then plants and bushes can be painted over almost immediately.

4

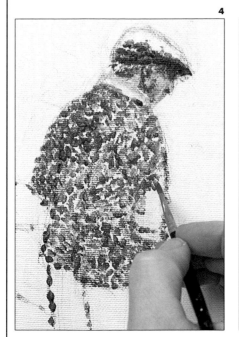

5

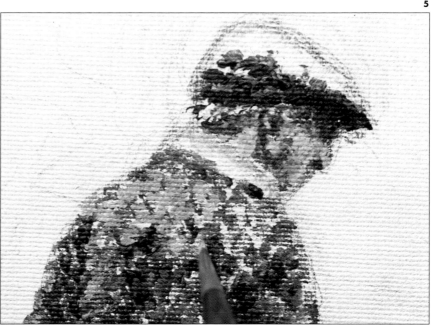

6

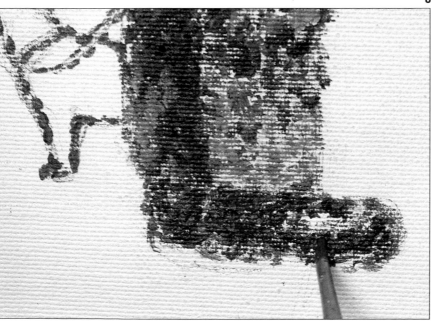

7

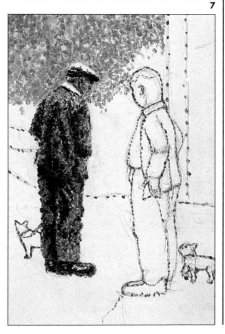

8 Continuing with the background, the artist uses sap green, sometimes straight from the tube and at others with titanium white. The copper beech tree is painted by laying carmine over burnt sienna.

10 A very light mixture of burnt sienna and white are used for his bald head, finishing with a few dabs of pure white for the shine.

8

10

9

11

9 The man on the right is given the measles treatment –dabs of cadmium red. To develop the volume of his head, sap green is used in the shadow areas, lemon yellow in the light, followed by burnt sienna mixed with titanium white.

11 His shirt is painted with Rembrandt blue and titanium white. Burnt sienna is then applied to the darkest parts of his cardigan. Rembrandt blue goes over the sienna to form the folds and darks.

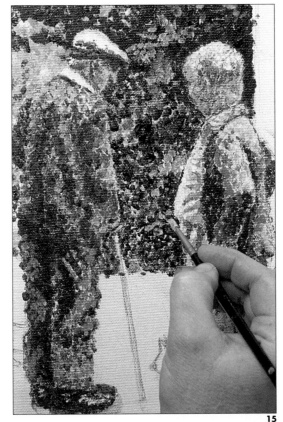

12 Titanium white with the slightest amount of Rembrandt blue is applied to the areas which are to be highlighted. These are the collar, the shoulders, the bottom back of the jacket and the forward elbow.

13 Working from dark to light the artist first establishes the folds in the trousers with burnt sienna. Over this she applies raw sienna. For the middle tones pure raw sienna is used. To finish the trousers raw sienna is mixed with titanium white and the highlights are applied.

14 Using a No.2 brush and a mixture of Sap Green and Titanium white the artist carries the background further using it to strengthen the edge of the right hand figure. Make sure that all edges butt up to each other.

15 The dark background helps to describe the shapes of the figures. The colours in the old garage doors on the right are ultramarine blue and sap green.

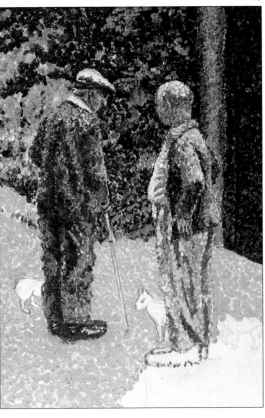

16 Continuing the technique of small brushstrokes of paint, the little dogs are portrayed. The darks are applied with ultramarine blue followed by burnt sienna and raw sienna. The tail end of the dog on the right is mostly titanium white.

17 The artist has painted the road with successive layers of ultramarine blue, raw sienna, carmine (mixed with white) and titanium white. The walking cane has also been painted in two values – a dark side (ultramarine and burnt sienna) and a light one (raw sienna with white) – using dots. The artist now paints the foreground grass using sap green, lemon yellow and titanium white in sequence.

18 Stepping back to examine the finished painting, the artist feels that she has painted the bald head too large. Oh!, the wonder of acrylic – she just extends the background colours to reshape the crown.

19 After all that dabbing, the painting is finished. What a vibrant picture this technique produces.

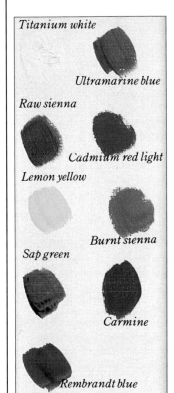

Titanium white

Ultramarine blue

Raw sienna

Cadmium red light

Lemon yellow

Burnt sienna

Sap green

Carmine

Rembrandt blue

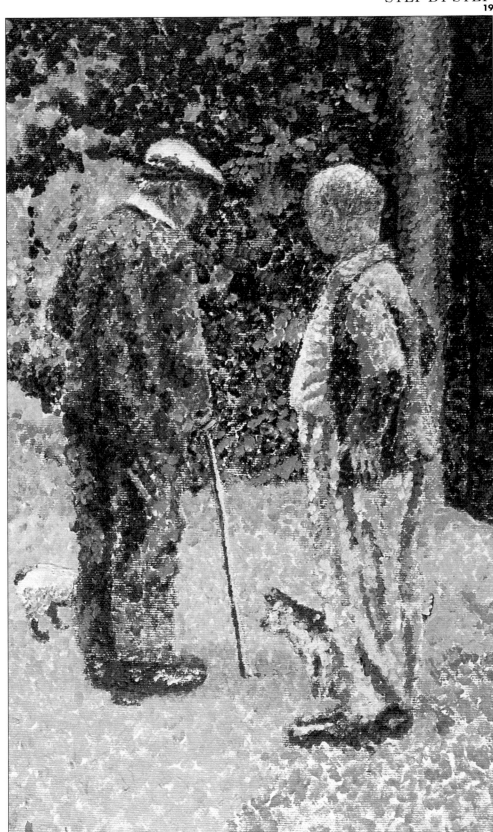

Self-Portrait
OIL TECHNIQUES

Most students of art have a desire to paint portraits but are often afraid to ask someone to model, so where better to begin than with a self-portrait. Set up a free-standing mirror very close to your easel and within 2 ft (60 cm) of yourself. It is very important when painting a portrait to be close to the model, whether it be self or other, as relevant detail such as eyes cannot be seen from the other side of a room. This is where portrait classes often fail; the room has so many easels set up that one cannot get close enough to the model. The artist in this instance feels that the eyes are the most important feature as they seem to express the character of a person. Time spent with a sketchbook studying individual features from different angles can be a great asset when it comes to the time to get out the paints. To attain a likeness, the planes of the face must be closely observed; these make up the actual face and give each of us our individual characteristics.

Painting portraits from photographs is a possibility if the photograph is very clear and large. Trying to produce a painting from a snapshot is almost impossible; normally the face is too small and features are just a blur, the shape of the eyes, nose and mouth impossible to see. It is also not advisable to paint a portrait of someone who is unknown to you from a photograph as people have many faces and one photograph will only show one of those. If you are acquainted with the person then not only do you have an image of that person imprinted on your mind, but you also have a feeling for them and this is what brings out the character in portraiture.

Acrylic paint is ideal for portrait painting. Because of the accelerated drying time skin tones cannot be overworked and made to look muddy, but retain their freshness. A hand accidentally brushed across the surface of the painting won't smear an eye or a nose which has been carefully painted. Paint retarder is introduced into this painting to slow down the drying times of areas that need some blending. This can be done with the brush or even with a finger. Retarder can prove to be very helpful in large areas where different values are incorporated, such as skin tones in the planes of the face.

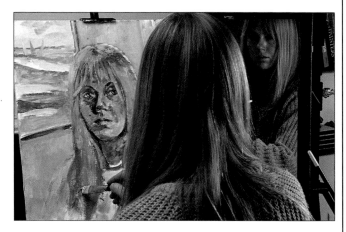

1

1 Sitting in front of a mirror, the artist makes a drawing of herself on a 20 in × 16 in (50 cm × 40 cm) fine-grain canvas using a 2B pencil. She begins by drawing the eyes: first the right, then the left. From these, she relates all the other measurements of the face, working outwards from the centre. This makes it easier to locate the contours of the face. The outline of the hair is added, then the shoulders and, finally, the background.

Materials: Fine-grain canvas 20 in × 16 in (50 cm × 40 cm); brushes – Nos. 2, 4 and 6 flat, Nos. 10 and 12 flat bristle; 2B pencil; disposable palette; water atomizer; paint retarder; rags or paper towels; 3 jars water.

2 In this painting, the painter is using a retarder to slow down the drying rate of the paint, enabling her to blend the paint if she wishes. This artist nearly always paints the eyes first when working on portraits. As with the drawing, it helps her to relate to the other features of the face and adds life to the blank canvas. She begins by painting the whites of the eyes with a No. 4 brush and titanium white, tinged with ultramarine blue; the whites of the eyes are never pure white but slightly blue/grey. Next, the iris: here she does not overmix the paint, so that it will appear on the canvas speckled as the iris normally is. The artist has brown eyes so she uses a mixture of burnt sienna, raw sienna and a little ultramarine blue. For the pupil, she does not use black, but a strong mixture of ultramarine blue and burnt

sienna; this closely resembles black. A little pink is painted in the corner of the eyes and along the bottom lid. For this, the artist uses cadmium red, titanium white and a tiny speck of ultramarine blue to dull the colour slightly. This is applied with a No. 2 flat synthetic brush. To add a sparkle to the eyes, the artist, using the same small brush well cleaned, very carefully adds the highlights

with titanium white. It is important not to overdo this as a white spot can easily look like a dab of paint and not a highlight, so it must be kept very small.

3 The artist puts in the tonal values. For this she uses raw sienna, burnt sienna and a touch of ultramarine blue. The white canvas is left for the lightest value; the mixture is watered down and applied for the mid-tone and used as it is mixed for the very dark areas. The paint is applied with a No. 12 brush in quite a free manner.

4 Before she progresses with the portrait, the artist feels that the background should be added. This constitutes an area of abstract shapes comprising mainly straight lines which lead the eye to the portrait. It is painted in neutral, low-key colours, consequently pushing the figure forward.

2

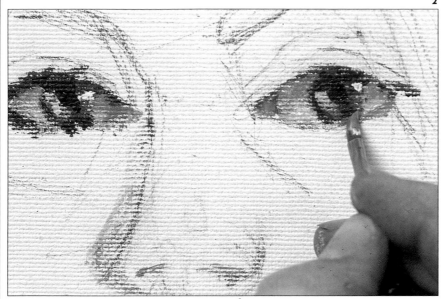

3

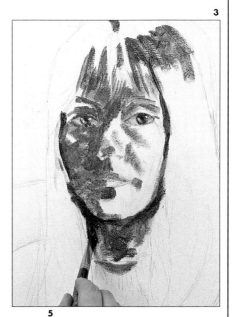

4

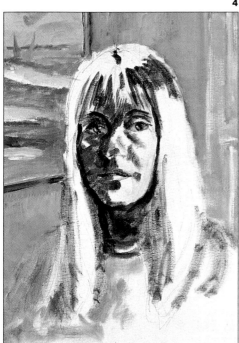

5

5 Using a No. 12 flat brush, the local mid-value stain colour is applied. For this, the artist uses raw sienna and cadmium red. This appears to be too bright so she adds a touch of ultramarine blue to tone it down. To this mix is added little of the retarder medium; it stretches the paint as well as slowing up the drying time. The paint is applied over the whole face and neck, lightly over the dark areas so as not to lose them. Dark and light areas are re-established, white is added to the paint used for the skin to paint in the light tones.

OIL TECHNIQUES/SELF-PORTRAIT

6 The artist looks into the mirror and scrutinizes the portrait so far, then she applies a mixture of raw sienna, burnt sienna and a small amount of ultramarine blue for the mid-tones of the hair. This is put on with a No. 12 flat bristle brush.

7 The darks are added to the hair using a No. 12 brush in long sweeping strokes, following the natural fall. Underneath the hair, around the face and by the neck it is very dark. This provides a strong contrast with the face.
NB It is important to remember to keep the brushes in a jar of water while not in use and also to spray the paints on the palette with the atomizer to keep them moist.

8 With a mixture of raw sienna and titanium white, highlights are added to the hair. The No. 12 brush is used sideways so that long thin strands can be applied.

9 Detail is added to the mouth. The line between the lips is strengthened, the top lip is darkened as it is in shadow, a small triangle of shadow which is apparent in most portraits is painted at the corners of the mouth, and a light line where the light catches the ridge on the upper lip is applied using the side of the brush.

6

8

7

9

10 Further detail is added, the area around the nose is strengthened and a little light is added for the shine on the tip. Noses are most difficult when painted from the front as they have no definite shape, not like the profile. The artist must observe the abstract shapes of light and dark to develop this area.

11 The sweater is painted quite loosely without too much detail; this will keep the viewer's interest on the actual face of the subject. A grey is mixed using ultramarine blue, burnt sienna and titanium white; darks are added by omitting the white and light areas by adding more. The silver necklace is painted using the darkest grey and highlighting it with white.

12 This is a very loosely painted portrait, completed in three hours. For the amateur artist wanting to paint portraits, where better to begin than a self-portrait; so much better than painting from photographs as you will learn a lot about skin tones, shapes of feature, etc. and also how to get character into your work. Working from a photograph is a poor substitute.

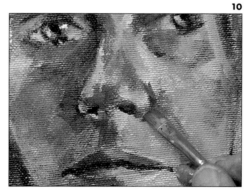

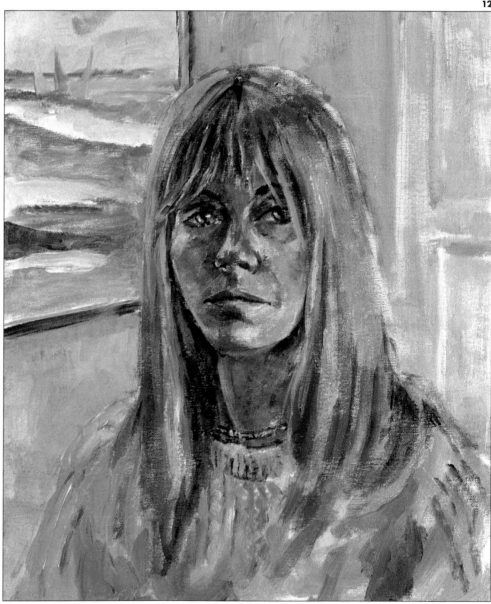

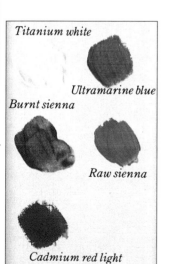

Titanium white

Ultramarine blue

Burnt sienna

Raw sienna

Cadmium red light

Chapter 8

The Beauty of Acrylic

In the previous two chapters we have described how acrylic paint can be used as a substitute for watercolour and oils. We are by no means suggesting that you throw away your other mediums. It is very important for the artist to remain versatile and adaptable, to be able to work in many methods and materials, thereby having the freedom to choose the most suitable technique to describe his subject. What this book intends to convey is that without a lot of expense and hoards of different tubes and pans of paint, the artist who uses acrylics has the freedom of many techniques and styles.

This medium stands alone as a unique material which has qualities that no other paint possesses. In this chapter we describe how it can be built up in a tonal manner, with flat areas of colour placed one over the other to produce the effect of three-dimensional volume. Because of the rapidity at which each subsequent layer can be applied, the finished painting has a spontaneous quality. The second painting in this chapter, 'Glass and Bottles', is developed in a very similar way to the 'Boy on the Beach' by the building up of tones, but here it is accomplished in tones of grey only, the colour being added last as a glaze. This was applied immediately the tonal painting had totally dried.

With acrylics, glazes can be completely transparent, the pigment thinned down with water or medium and applied in the same manner as the colour in the wine bottles on page 124, or the glaze can be semi-transparent to create an effect of distance, delicacy or atmosphere. This is created by adding a touch of white to the thinned-down coloured glaze.

This technique was used in the background of the painting 'River Scene' which is illustrated in this chapter. Using a technique peculiar to acrylic paint, the artist has broken the composition down into three areas, transferring each section from a tracing paper drawing after the previous area has dried. Figures are added simply by the use of brushstrokes depicting form and colour, void of detail. By close observation you can see that the figures, although convincing, are merely dabs of paint.

These paintings describe just some of the variable uses of acrylic; try these and experiment for yourself. Acrylic paint is a new medium in comparison with other paints; perhaps you will discover a virtue of the medium that no one else has.

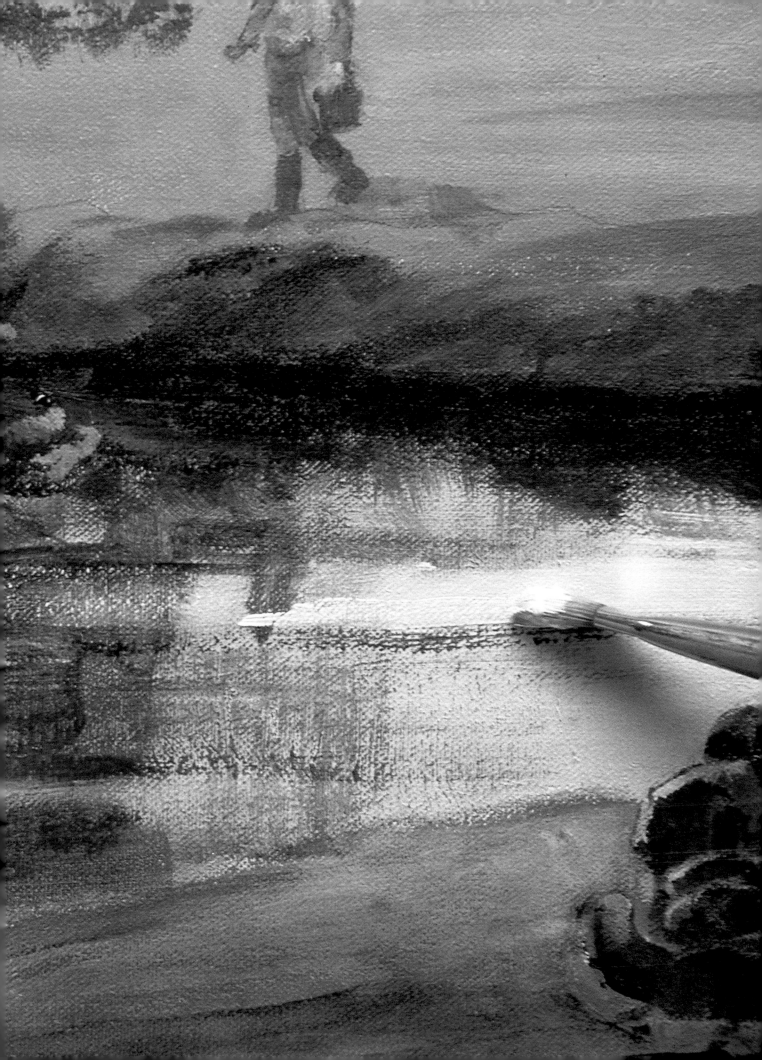

GLAZING

A glaze is a transparent or semi-transparent coat of paint applied over another colour, which must be perfectly dry, to get certain effects. Transparent oil paint is the traditional medium to use for glazes, but a drawback is that oils take so long to dry. With acrylics glazes can be applied almost instantly. This is especially advantageous when it comes to applying several glazes one over another. The Old Masters who developed this technique had to wait weeks, sometimes months, between each glaze. Another disadvantage to the glazing of a painting with oils is that

1 A board has been coated with yellow acrylic paint. It is then divided into four sections: one quarter is left yellow, while a glaze of ultramarine blue acrylic paint mixed with gel medium is applied thinly over the other three quarters of the painting. This is allowed to dry and then burnt sienna is mixed very thinly with the same medium. This is glazed over half of the board, allowing one quarter of the board to show as yellow and one quarter green where the ultramarine blue glaze is left. By applying one glaze over another, we now begin to get some interesting colours. On the last

quarter of the board an additional glaze of ultramarine blue is added; this gives the appearance of a grey colour with many other hues — yellow, green, blue, burnt sienna — and in various tones. The possibilities of glazing are endless. It can by employed in many ways — for shiny metal (brass, copper, silver, tin etc.), glass (both coloured and clear), water, or fabrics such as silk and velvet.

When glazing, it is important that the surface be clean, entirely free from dust and perfectly dry.

they are likely to be removed at some future time, when the varnish of the picture must be removed to clean it. With acrylics, this will not occur as acrylic varnish does not yellow or crack and the picture can be satisfactorily cleaned simply by sponging over with a solution of soap and water.

2 This paste-like gel medium makes acrylic paint more transparent and glossier. The consistency and colour brilliance of the paint hardly change at all. It can be added without limit.

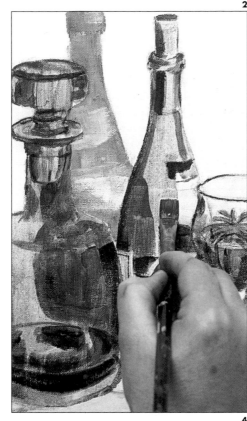

1 The artist's subject of wine bottle, glass and port decanter have been drawn on to a canvas and are being prepared for glazing by employing a monochrome underpainting.

2 After the dark shadows have been applied, thinner glazes of the monochrome underpainting are added.

3 A second glaze of green, sap green, and ultramarine blue was applied to the whole bottle. After this had dried, the artist felt that the area containing the wine was not yellow enough, so a third glaze of sap green and lemon yellow was applied. Each glaze was thinned with gel medium to a very transparent quality.

4 After the final glaze has dried, opaque highlignts are added. Do not destroy the beauty of the transparent paint by overstating the opaque.

Boy on the Beach

THE BEAUTY OF ACRYLIC

Children are always a delight to portray; their soft features and lithe bodies have inspired many artists. This subject is chosen to demonstrate a straightforward approach to painting in acrylics, using a building-up technique of flat areas of colour.

A square canvas was chosen for the support as it emphasizes the shape of the figure. The square support is not utilized as often as the rectangle as some artists consider the square too static with both sides measuring the same. In painting, it is an asset to keep an open mind and to experiment with any different ideas. We could take example from Anthony Green RA, the contemporary artist who uses all kinds of configurations in the form of supports. More important is the composition within that shape. Keeping the negative space (the area surrounding the subject) to a minimum, the artist in this painting has drawn the figure rather large, filling the best part of the canvas. She has made the negative shape positive by adding interest to it with design, colour and brushwork.

Further to this, the figure is placed to the left side of the canvas, his body facing into the wider area on the right, along with the shells. This makes this area of the painting interesting and positive.

The painting is built up quite effortlessly. All areas are painted in a flat middle tone, dark areas are added in flat definite shapes as they are observed on the figure and the painting is completed by adding passages of light in the appropriate sections. Despite the fact that each area is painted in only one value, texture is achieved by the artist using interesting brushwork which remains quite visible to the viewer.

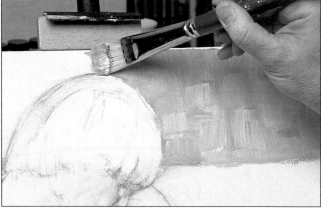

1 On fine-grain canvas with a 2B pencil, this drawing was made of the figure of a boy, taken from a photograph of two children photographed by the artist some time ago. The outline drawing is placed to the left of the canvas allowing space in front of the figure which is drawn large enough to almost fill the square canvas. This image lends itself to the square, which is a refreshing change from the norm of oblong canvases.

Materials: Fine-grain canvas 18 in × 18 in (45 cm × 45 cm); brushes – Nos. 10 and 12 flat bristle; 1 in (25 cm) wide glazing brush – any soft brush will do; 2B pencil eraser; disposable palette; rags or paper towel; 3 jars of water; acrylic gel medium.

2 Other than the drawing, no other preliminaries were employed. The artist paints with full thick paint, mixed with a gel medium, straight on to the primed canvas, building the painting up with large flat areas. With a No. 12 flat brush, she applies a mixture of Rembrandt blue, ultramarine blue and titanium white to the sky area in a cross-hatching manner. The only variation in the sky colour are the marks of the brush and the lights and darks of the not overmixed paint on the brush.

3

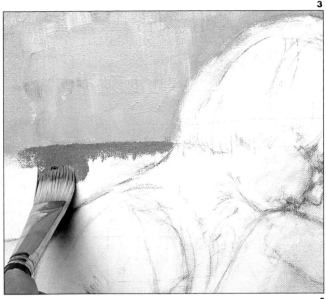

3 Rembrandt blue with a touch of burnt sienna to dull it, plus titanium white, is the mixture applied to the sea. Note how the artist paints a very straight hard edge where the sea meets the sky.

4 Where the sea and sand meet, the artist drags the brush to make an uneven edge. The brush is a No. 12 bristle used boldly in definite brushstrokes, brushed this way and that.

4

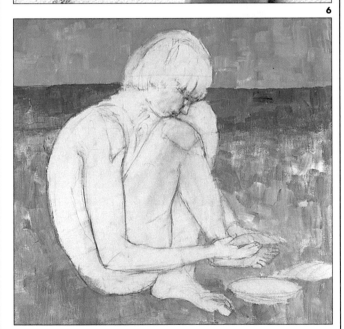

5

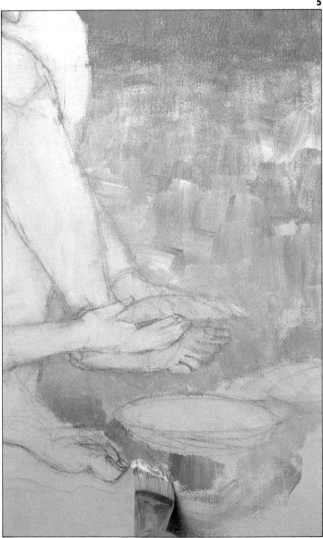

6

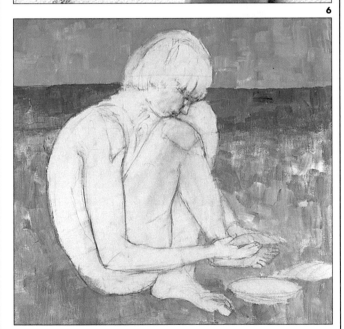

5 This painting is developed in flat shapes of colour. The sand is one flat area of raw sienna and titanium white. This colour is brushed into the rough area where the sea meets the sand, thus giving the appearance of the water washing over the beach.

6 The background is painted; the artist stands back to take a long look. Detail has been kept to a minimum so as not to draw the eye from the figure.

7 For the flesh colour, the artist has mixed cadmium red light, raw sienna and titanium white which she lays on with a No. 10 bristle brush in a very flat manner, disregarding any figure structure, but allowing the drawing to show through in just enough places so as not to lose it.

8 The middle tone of the hair is painted in much the same way as the body. Using pure raw sienna, the artist paints the area flat with long brushstrokes describing the roundness of the head. She then paints in the basic hue of the shells with burnt sienna, ultramarine blue and white.

9 Once again the artist views her work – a very important step in the process of developing a painting. Often obvious mistakes cannot be seen close up, but once the painter steps back the error will stick out like a sore thumb. At this stage the whole canvas is blocked in with abstract shapes of flat colour.

10 A transparent glaze is used to apply shapes of dark to the figure. The features are carefully depicted and the profile strengthened by the addition of a shadow on the far knee. To do this, the artist mixes ultramarine blue and burnt sienna with an acrylic gel medium. This thins the colour of the paint but not the consistency.

11 Using the same mixture, the artist applies darks to the hair and to the shells. In both instances, she uses the brush to describe the shape by pulling long brushstrokes around the curve of the image.

12 Small details of light are added to the face in definite shapes, brushstrokes are left unblended. More light areas are added to the body in flat, hard-edged, abstract shapes.

13 The impression of fine strands of blond shiny hair is the next step. This is achieved by dragging a rather dry brush, dipped into raw sienna and titanium white, over the darker areas.

10

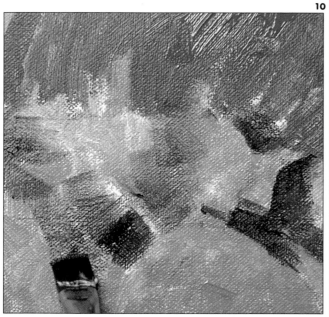

11

12

13

14 A close-up detail of the head and shoulders shows how, with three values, the artist has built up the painting so far. Some knowledge of figure drawing helps when attempting to capture the human form.

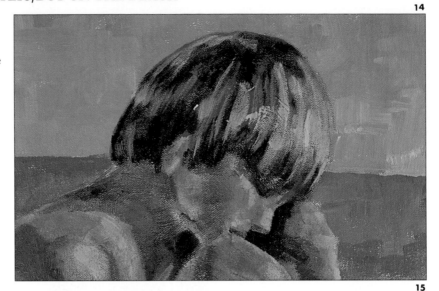

15 The dark areas of the shells are strengthened and the bright edges are highlighted.

16 With a glaze of ultramarine blue, burnt sienna and gel medium, the artist applies shadows to the painting – under the shells, on the sand beneath the figure, and slightly over the lower part of the body, close to the sand. These she applies with a clean No. 12 brush.

17

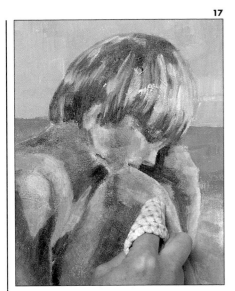

17 When all is dry, the artist mixes a warm thin glaze of cadmium red light and raw sienna. This produces a lovely orange-like colour. This she applies to the whole figure to give the skin a warm glow. In places she wishes to remove it to highlight sections. This is simply achieved by wrapping a soft rag around the index finger and wiping off the excess paint.

18 Painting figures is quite an ambitious task, but not beyond the realms of anyone. Attending life-drawing classes can be a great help. Here the artist demonstrates how after you have completed your drawing the painting can be quite simply developed in easy-to-follow steps.

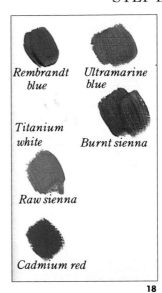

Rembrandt blue

Ultramarine blue

Titanium white

Burnt sienna

Raw sienna

Cadmium red

18

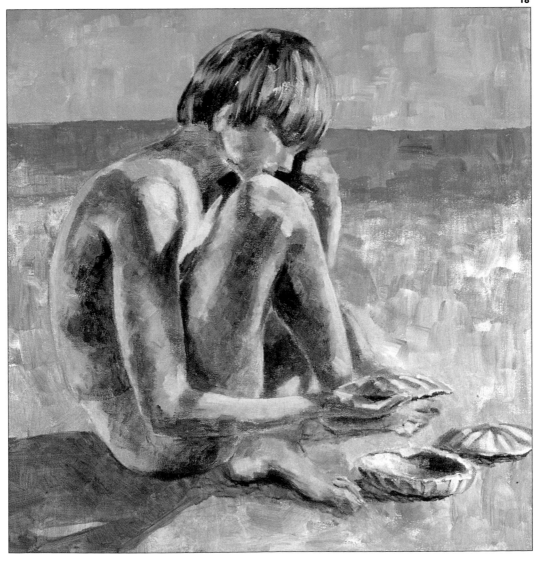

Glass and Bottles

THE BEAUTY OF ACRYLIC

Art students can feel intimidated by a still life of glass objects – very often beginners will say, 'how can you paint glass, it hasn't any colour'. They tend to forget that it is transparent, that the colour of articles around and behind will be reflected onto its shiny surface or seen through its body. The painter should try to remain objective and to look at the subject in an abstract way. Within the outline of a glass or bottle is an arrangement of shapes, light and dark, and it helps to delineate these while making the initial drawing. Even if the underpainting covers the lines, the mind will have a mental picture and will be reminded to add these shapes. Preliminary sketching is a great help to the artist; time spent studying and sketching the glass objects on a piece of scrap paper or in a sketchbook will add to the success of the finished painting.

Contrast is of paramount importance in the rendering of glass objects, with light and dark shapes juxtaposed. Often the beginner painter will shy away from darks, being afraid that they will 'ruin my painting', where, in fact, just the opposite will happen. There cannot be dramatic lights if there are no darks as there will be nothing in the painting to produce a contrast. The Italian word 'chiaroscuro' describes the arrangement of light and dark in the picture, the dramatic quality of form relieved by light against dark.

In this painting, the artist has used chiaroscuro to develop the picture before adding any colour to it. The colour is added in the form of glazes: thin passages of colour suspended in an acrylic medium which makes the paint transparent but does not thin its consistency.

These glazes are then applied over the monochrome painting with a soft brush. This is a technique that has been used for many years by the Old Masters, but until the arrival of acrylic, always with oils. It is very important to apply a glaze over dry paint, so the practice of building up glazes was a lengthy process due to the drying time of oil paint. In this painting the artist was able to add the first glazes almost immediately after completing the monochrome painting. A second glaze of yellow over the wine in the green bottle followed immediately after the green glaze had dried – a matter of minutes. The painting was then quickly finished by the touches of opaque white paint for the (sparkle of glass) highlights. One must be very careful not to overdo the opaque highlights in a glaze as it can quickly take away from the delicacy of the luminous colours.

Materials: Canvas board 12 in × 16 in (30 cm × 40 cm); brushes – Nos. 4, 8 and 10 flat synthetic, 1 in (25 mm) wide glazing brush – a wash brush can be used; 2B pencil; eraser; disposable palette; rags; 3 jars of water; water atomizer for keeping paints moist; acrylic painting medium.

1 This still life was set up to demonstrate a technique of painting glass: plain, coloured and cut crystal. The objects are placed on a white tablecloth and against a white background. A strong light source throws interesting shadows on to the wall and also adds more life to the glass by adding sparkle.

1

2

2 The drawing which fills the greater part of the canvas board is developed using a 2B pencil. The artist uses her pencil and an outstretched arm to work out the sizes of the objects in relationship to each other. She begins each object by breaking it down to basic forms: for example, the wine bottle is first divided into a cylinder with a cone on top and is developed further from there. The easiest way to get both sides of a symmetrical form equal is to draw a line down the centre and to measure the width of each side from it.

3 To begin this painting the artist first applies the dark areas, and at once the objects begin to look like glass. When rendering glass, it is very important to paint the darks very dark so as to provide a strong contrast when final lights are added. Many people are confused by the idea of painting clear glass, thinking it an impossibility. There is no trick to it, the painter must look and observe carefully all the shapes and colours and apply them.

4 The shadows have been painted into the background with the two colours that were used for the darks in the glass. Lemon yellow and white are now painted quite thickly all over the backdrop, the shadows are scumbled over with the same mixture and brought right up to the edge of the glass objects.

5 Using an acrylic painting medium and a medium grey made with ultramarine blue and burnt sienna, the artist glazes over all areas of glass. The glaze is fairly thin, allowing the darks to show through.

6 Folds are added to the tablecloth with definite brushstrokes, using the grey glaze. The artist then stands back to check the monochrome painting; is it ready for the colour glazes?

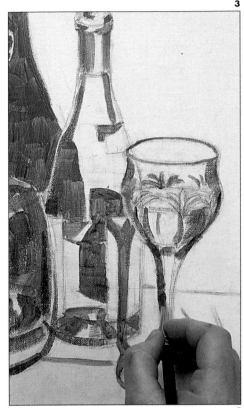

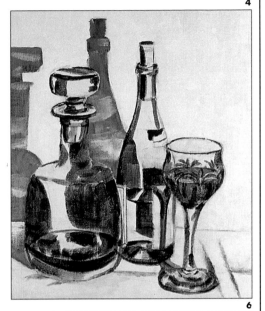

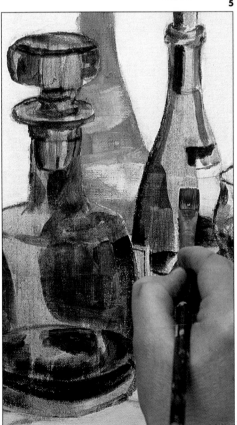

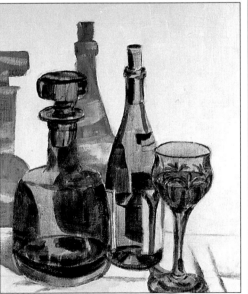

7 Satisfied with her work, she progresses. A rich ruby port colour is mixed with carmine and ultramarine; this is too violet and so the artist adds a touch of burnt sienna, just right. This glaze is applied to the wine glass and also to the decanter using a 1 in (25 mm) wide hair glazing brush.

NB A glazing brush is not a necessity. Glazing can just as easily be accomplished with a large soft brush of any description.

8 Sap green is added to a little painting medium to provide a glaze for the bottle. This same colour is reflected in the port decanter, a little in the foot of the wine glass and quite a bit in the shadow on the wall.

9 The glass has quite a yellow tinge where the wine is still in the bottle so, mixing lemon yellow with a tiny touch of burnt sienna into the acrylic medium after the green is dry, the artist applies a second glaze. It is possible to build many glazes up in one area so long as the previous one is completely dry. If using oil paints, this would mean waiting days in between instead of minutes as with acrylics.

10 It is now time to add sparkle to the glass. For this, the artist adds a speck of lemon yellow to titanium white. This will warm the white slightly and it will appear brighter than pure white. To apply it, she uses a No. 4 flat brush, being careful not to overdo this stage.

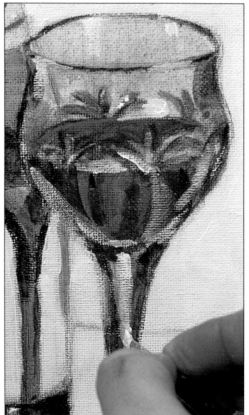

11 Finishing touches are added. A brushstroke of pure cadmium red light is applied to the liquid in the decanter and the glass to create a glow where the light is shining through.

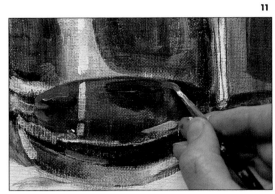

12 To finish the painting, the artist paints a dark shadow to delineate the back of the table. This she gently blends away, upwards. Shadows are then added on the tablecloth behind the decanter and also behind the glass.

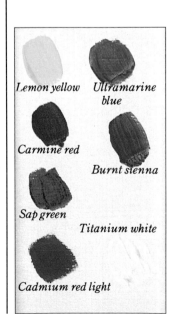

Lemon yellow Ultramarine blue

Carmine red

Burnt sienna

Sap green

Titanium white

Cadmium red light

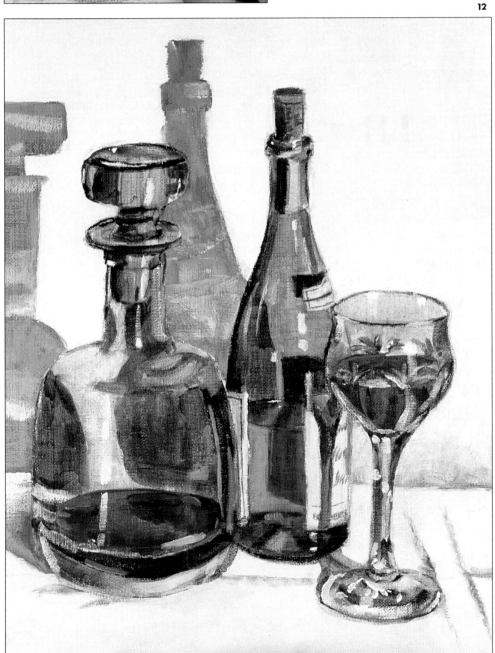

River Scene

THE BEAUTY OF ACRYLIC

An idyllic scene, a warm summer's day, cows in the pasture, fine for a walk or a picnic by the river, an activity most of us would like to participate in. But what a complicated subject for a painting? No, not at all. By following this demonstration, you will see how this artist breaks it down into simple elements.

This painting was developed in the studio, which is obviously easier than painting out of doors. It is, however, essential to the landscape painter to go out and to study his subject at first hand. The outdoors provides a wealth of subject matter, every nook and cranny offer the possibility of a painting. When going on a painting trip, it is important to keep materials to a minimum. One small rucksack should carry everything including the sandwiches, with the exception of an easel which can be carried on a shoulder strap, leaving hands free to open and close gates, climb fences, etc. Acrylic paint is the ideal medium for the artist on location as its unique character gives the painter several choices: to paint thickly in oil-colour style, to thin the paint right down and use it as you would watercolour, to use it fluid with a small brush like ink or line and wash, to sketch with it or to use it in a very quick spontaneous manner, perfect for acrylic.

Consequently, a sketchbook of reference material – skies, trees, hedges, animals, etc. – will be of great value back in the studio where you will perhaps want to develop your studies into more monumental works. A small camera kept in the rucksack often comes in handy, especially for photographing people or animals in action: a horse and rider galloping through the woods, children playing, a boat on the river. All these subjects move too fast even to contemplate a sketch, so here the camera is indispensable; it stops the action for the artist, allowing him to make his sketch from the photograph at a later date.

Landscape artists tend to be attracted to water; perhaps it is the challenge of the reflective, often moving, surface that appeals. Those just beginning to paint tend to shy away, feeling the subject too difficult to tackle. Leaving the area of water until almost last, this demonstration shows how water can be broken down into lights and darks, and simply rendered. The artist, with half-closed eyes, identifies as closely as possible the middle tone, painting it in a flat layer. Observing again she classifies the light and dark areas and paints them in. A question often asked is 'What colour is water'. To the painter, water is what it reflects; a moving pattern of colour, lights and darks. Detail is best kept to a minimum in reflections, objects suggested rather than described. Tones kept generally *en masse* rather than fragmented will maintain the peaceful tranquillity that water transmits in a painting.

Materials: Canvas 18 in × 30 in (45 cm × 75 cm); brushes – Nos. 10 and 12 flat bristle, No. 4 flat synthetic, No. 1 watercolour rigger; tracing paper; pencil; conté crayon, putty eraser; ballpoint pen; disposable palette; 3 jars water; water atomizer; rags or paper towel; matt acrylic medium.

1 Working from this photograph of students by a river, the artist shows how with acrylics a painting can be developed one area at a time. She also demonstrates how to paint water and figures in a landscape.

2 The horizontal composition is drawn onto a piece of tracing paper the same size as the canvas – 18 in × 30 in (45 cm × 75 cm). As this is quite a complicated painting, depicting several elements, it is easier to develop the drawing on to the tracing paper and transfer it a section at a time. This is only possible with acrylics on canvas: oil paints are so slow to dry that it would take the artist forever to complete a picture. Another advantage of this technique of drawing on tracing paper is that it saves a lot of rubbing out and putting pressure on to the canvas. After the drawing is complete the artist goes over her lines at the back of the paper with conté crayon or chalk. At this stage only the main areas of the painting are transferred.

1

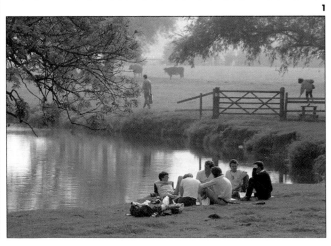

2

3 To keep the impression of a misty distance, the artist paints the sky a warm grey. For this she uses raw sienna and ultramarine blue, painting in quite a flat manner. Matt acrylic medium is used throughout this painting. Paint is applied in most areas in its final tone; no underpainting is employed. The distant colour is achieved by adding a little sap green to the sky colour. As the artist works toward the bottom of the canvas (the foreground) she gradually strengthens her greens with more sap green and the addition of ultramarine blue.

4 The sky and land areas dry, the artist, after first going over the back of the lines with conté crayon, traces in the middleground objects -- trees, cows, man and gate. To do this a ballpoint pen is used, which

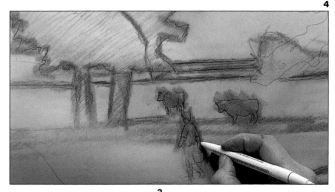

4

3

enables her to visualize which lines she has already transferred. In addition, it provides a finer drawing on the canvas than other implements would imprint.

5 With a mixture of lemon yellow, ultramarine blue and titanium white the artist paints the trees on the left of the picture plane. The colour is kept soft and misty to imply the impression of a hot misty afternoon in early summer. Continuing with the middleground, the cows are added. Using a No. 4 flat synthetic brush the cow on the left is painted using raw sienna, ultramarine blue and titanium white.

5

6

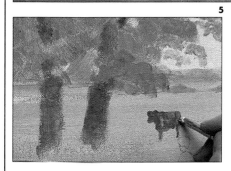

6 The middle ground is progressing. With ultramarine blue, titanium white and burnt sienna the artist paints the cows, the man's hair and the gate. His clothes are ultramarine blue and white and flesh burnt sienna and white. Burnt sienna and ultramarine blue suggest a shadow under the trees.

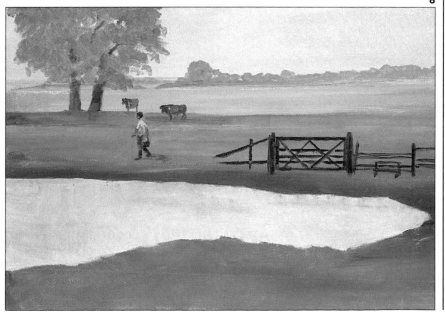

7 The tracing-paper drawing is reapplied to the dry painting – and all other elements – figures, trees, reflections – are transferred onto the canvas. Detail is then painted into the riverbank. Burnt sienna and raw sienna are used on a No. 12 flat bristle brush for the muddy bits; ultramarine blue, burnt sienna and sap green for shady grassy areas.

8 The middle value of the figures is now painted. Various blues and greys mixed from ultramarine blue, burnt sienna and titanium white are used. To do this, a No. 4 flat synthetic brush is employed.

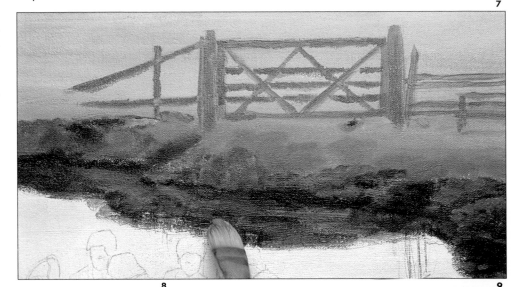

8

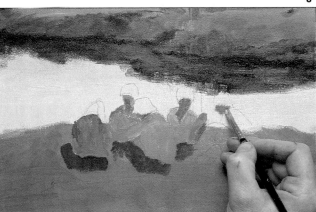

9

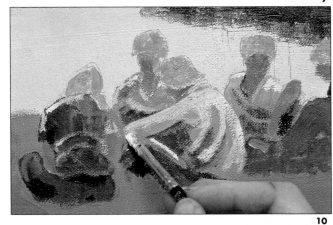

10

9 The dark value has been added to the figures and now the artist adds the highlights.

10 The figures are completed by adding rugs beneath them. One is raw sienna and white with a little blue detail added, the other burnt sienna and white. A dark shadow is applied underneath to give the impression of the rugs being rumpled. For this the artist used ultramarine and burnt sienna. The detail in the figures is kept to a minimum so as not to detract completely from the rest of the painting.

11 Branches of the left foreground tree are painted in with burnt sienna and ultramarine blue. A No. 10 rigger brush is used for the larger branches and a No. 1 for the smaller ones. The rigger brush is a wonderful aid to the artist once he has mastered it. It is quite a good idea to practise with it on a piece of scrap paper. This artist finds that for painting branches, gently pushing the brush with very wet fluid plaint gives the desired effect.

12 With a No. 12 bristle brush and a paint mixture of sap green and burnt sienna, the artist paints in the darkest leaves. For the middle value she adds lemon yellow to this mix, finally adding titanium white for the lightest leaves. The brush is used in a stabbing motion, allowing the bristles to spread out as they meet the canvas.

13 Short vigorous diagonal strokes using the side of a No. 10 bristle brush with a grey green paint mixed from ultramarine blue and raw sienna is the formula for the weeping willow tree on the right-hand side of the canvas.

11

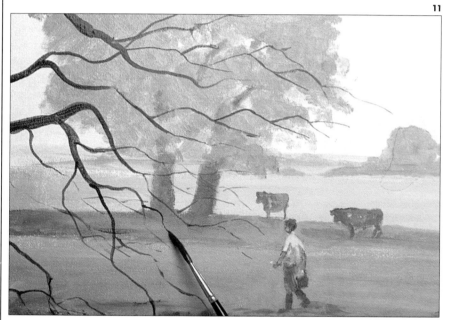

12

13

14

14 The artist steps back to scrutinize her work which is progressing rapidly. When painting a landscape with water, this artist leaves that area until last, so that she can adjust the tone of the painting, either lighter or darker. In this instance, she sees, when standing back, that the painting has an overall dark tone, so to balance this she decides to keep the general value of the river light, creating tonal balance and contrast within the composition.

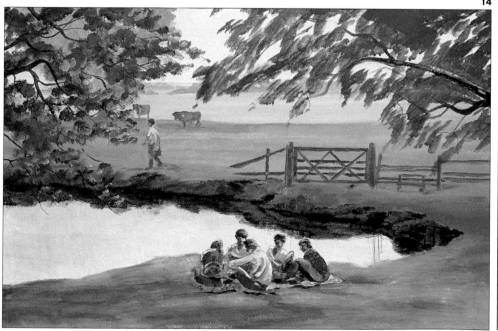

15　With a No. 12 brush and a grey green (raw sienna and ultramarine blue) mixture of paint the artist scumbles (see pages 37 and 136) the paint on to the canvas in vertical strokes and then with a dry No. 10 brush rapidly blends the paint horizontally, depicting reflections of the overhanging tree in the water.

16　Directly below the gate, and using the same colours that were used to paint it, the artist paints the reflection in the bend of the river. A little ultramarine blue and burnt sienna is used to describe the reflection of the walking man.

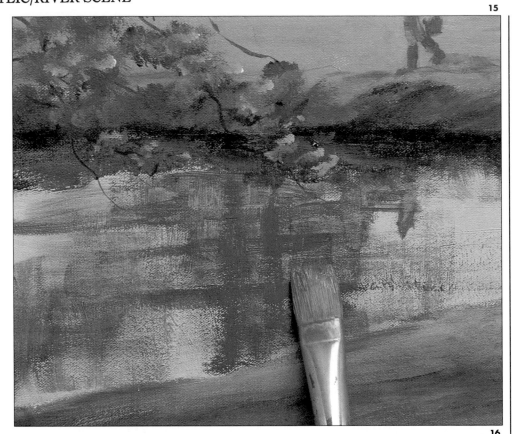

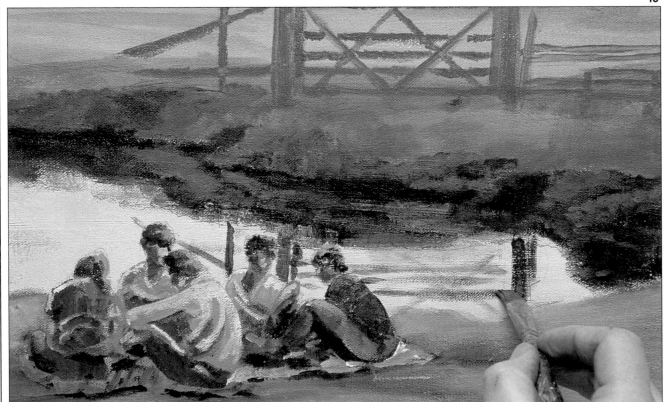

17 As a final touch, white paint is lightly and minimally scumbled horizontally to add water.

18 The horizontal composition in this painting and the dramatic dimensions of the support add to the theme of repose and peace. The horizontal shape as opposed to the square or shorter oblong shape creates a feeling of calm and restfulness and the lines in this painting only add to that.

17

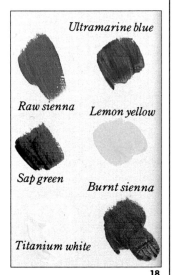

Raw sienna

Ultramarine blue

Sap green

Lemon yellow

Burnt sienna

Titanium white

18

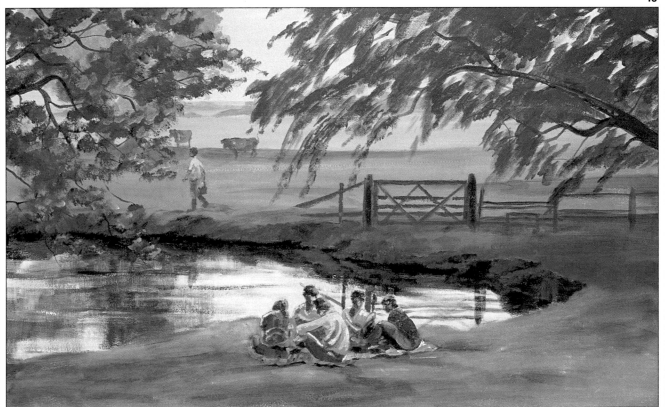

Chapter 9
Further Techniques

In this chapter we show how acrylics can be used in mixed-media painting, as a sketching medium and, finally, applied with devices other than brushes to render textures.

For mixed-media painting, the artist has decided to do a figure study. Beginners will perhaps think this subject too difficult to tackle – not so. When drawing and painting one must keep an open mind and look at the subject objectively. Painting the figure is no different to approaching a still life or landscape. The artist observes the individual shapes of any subject; the figure like the landscape, is made up of curves and angles, areas of light and dark, and shapes of different colours. Look at your subject with squinted eyes to cut down on detail, observe the large flat areas and draw or paint them. Of course, it does help to go to a life-drawing class. By doing this, your ability to draw will increase rapidly. Painting is an extension of drawing; it is essentially drawing with a brush and using different colours other than black and white.

For the second demonstration, the artist shows how you can actually use acrylic paint with a brush and still produce what we think of as a drawing. The paint thinned to this extent could also be applied with a quill pen or even with an airbrush.

Many illustrators use acrylic paints for their airbrushed works.

Finally, we demonstrate how this paint can be applied in ways other than with a brush. To illustrate this, the artist sets up a still life of textured objects in the studio and then adds an imaginary background to complement the subject. A sponge is used to create the illusion of gravel. Painting with sponges (see page 137) is not a new idea but is most often employed by watercolourists. It is possible when using this medium to produce a whole painting with sponges. A palette knife is also used in this painting (see page 152). These come in a multitude of shapes and sizes and it is really up to the artist which he chooses for himself. As with sponge painting, many artists produce complete paintings with the palette knife alone; this produces quite a thickly textured painting.

Murals are often painted with acrylic because it can be painted on to almost any surface, so it is the ideal paint for such projects. Indoor murals can be painted directly over an ordinary household paint undercoat.

Outdoor murals are a little more tricky; the wall to be painted on needs to be prepared and treated first to ensure that the mural stands up to the elements.

WIPING OUT

In the technique of 'wiping out' acrylic paint is used only for the underpainting and allowed to dry. Opaque pastel oil colour could be used in much the same way, but would probably take two weeks to dry instead of a matter of minutes. Soft pastels can also be used as an underpainting to oils, but must be made fast with a fixative. When using this wiping out of oils technique, it is advisable to use only transparent colours. This enables the colour of the underpainting to shine through to a certain extent. It becomes quite easy to recognize the transparent oils as opposed to the opaque ones; often this information is marked on the tubes. Passages of transparent paint are known as glazes (see page 114). By lifting areas of glaze from the painting, you are exposing the coloured acrylic ground underneath, representing the middle-tone value. The remaining glaze encompasses both the middle-tone darks and the darkest darks. Lights are added to this middle value by means of very light opaques in the final stages of the painting. Muslin cheesecloth is ideal for wiping out, but any soft rag will do.

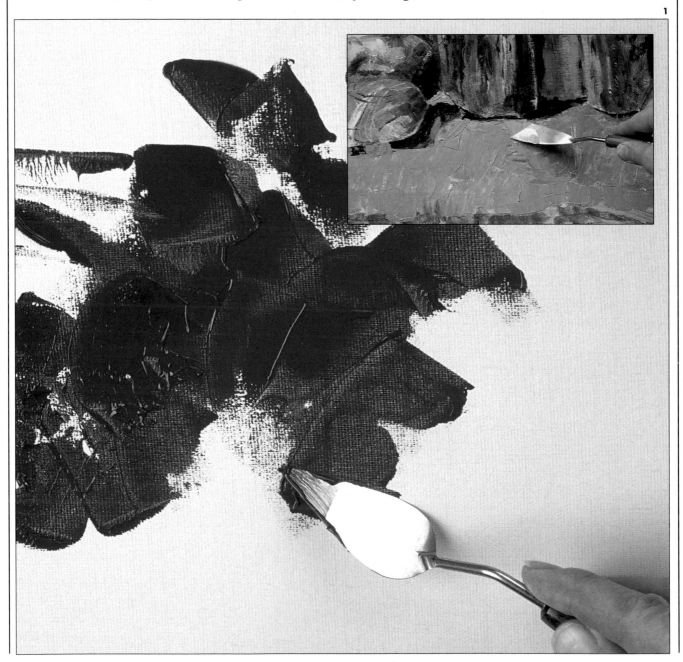

1

USING A PALETTE KNIFE

Although commonly called a palette knife, the trowel shaped knife is actually known as painting knife. A palette knife has a long blade similar to a butter knife but more flexible and is used for mixing paint on the palette. The painting knife, on the other hand, comes in many shapes and sizes. It is very flexible and can be used for areas of a painting or to render a complete painting. It is a good idea to experiment with different types of knives – flat-ended ones, rounded, wedge shaped or pointed, large or small. Of course, it makes sense that if the painting is to be on a large scale, then you would use a larger painting knife.

1 A pointed, trowel shaped painting knife is used to spread ultramarine blue paint liberally on to the canvas.

2 A flat-ended palette knife is utilized to spread paint in an area of stone in a painting that has been rendered with brushes as well as knives.

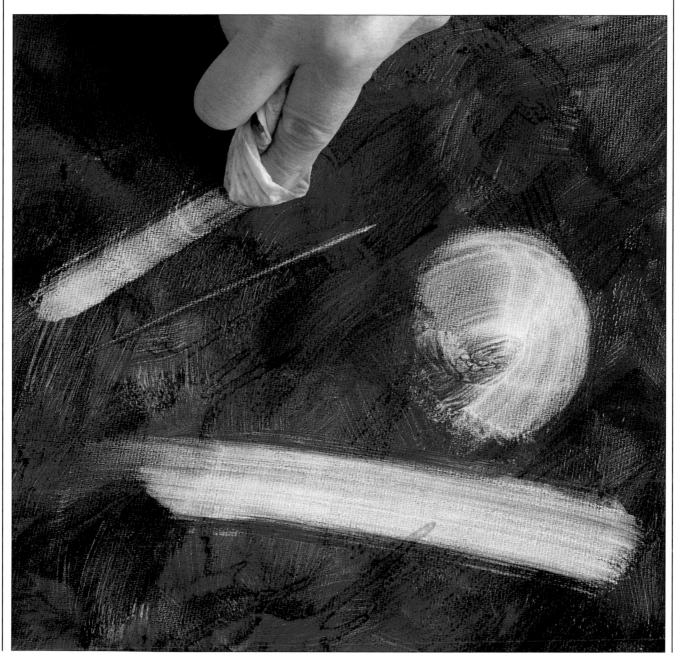

135

SCUMBLING

A scumble is a semi-opaque layer of light colour applied over a dry layer of a darker colour, usually opaque. A scumble resembles a light-coloured veil, partially obscuring the underlying colour. When scrubbing with light paint over dark it is a good idea to use a brush that is old as the vigorous motion may cause hairs to break off. If they do, just brush them off the canvas. For a transparent scumble, such as lace curtains blowing in the breeze against a dark background, mix colours with an acrylic medium, a lot of white and a little water and scrub on using your old brush.

Below is an example of scumbling: first, light over dark and quite opaque; second, the light scumble is fairly transparent; and the last example shows dark colour scumbled over a light background.

The small detail shows where scumbling has been used in a painting using both light and dark paint.

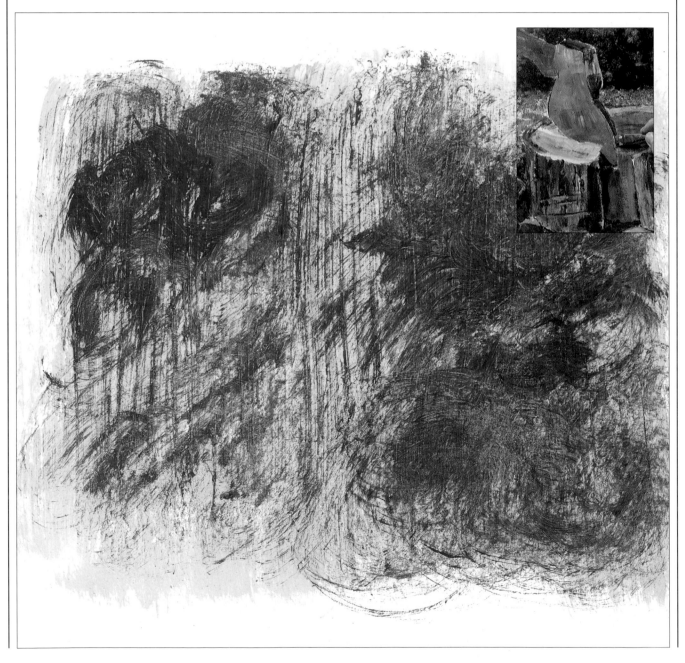

The sponge is a very useful tool for the artist. Commercial sponges are just as good as natural ones for this job and far cheaper. The textures that one can crate with a sponge are endless – fluffy clouds, sea surf, sand, gravel, flaking walls. Regular patterns, like concrete slabs, wooden boards and fences, can be painted with a flat-edged sponge. Shape the sponge with the scissors or pull it to pieces with your hands. For regular patterns, board etc., dab the sponge on to the canvas holding it the same way each time. To create an uneven covering, turn the sponge slightly each time you touch the picture surface.

When buying sponges, think of the colour. To see the amount of paint you are applying dark sponges are better for light paint and light ones for darker colours. Don't forget that after use they must be well rinsed out.

Here the artist, using a torn piece of sponge and ultramarine blue, creates an uneven texture by slightly turning the sponge each time it is applied to the canvas.

This demonstrates how the artist creates the textures and colour of a pebble path by using different colours, and applying them unevenly.

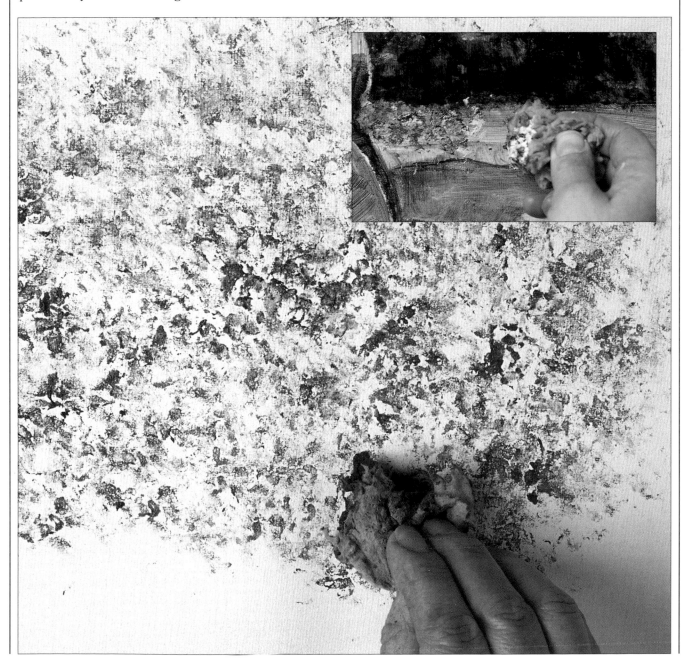

Female Figure
FURTHER TECHNIQUES

Using the female form as a subject, this painting describes how acrylic paint can be used in a mixed media composition. It is exciting to use conventional materials in unconventional ways and to experiment with different ideas. The drawing in this painting is as much a part of the completed work as the applied colour. The charcoal drawing can be identified on the finished surface along with the acrylic ground which surfaces throughout the oil glazes. To carry the unusual a little further, the artist has decided to use an unconventional canvas, the long narrow shape lending itself perfectly to the attitude of the model. High contrast is produced by using a strong, low lamp by the head of the figure which, when translated into the painting, describes the technique of lifting out dark glazes to expose the light acrylic underpainting.

A little knowledge about materials is essential to this type of painting. There are many variations of soft mixed media that can be used by the artist and which will work well together. Likewise, there are those that will not, and results can be disastrous. Oil paint can be used over many other materials – pastels, gouache, watercolour, acrylic – but very few painting mediums can be used over oil. Acrylic paint makes an ideal ground for oils. The oil paints employed in this demonstration are only of a transparent quality with the exception, of course, of white, so allowing the drawing and underpainting colours to show through and contribute to the finished work. It would be helpful to the student to spend time learning to distinguish between the transparent paints and opaque ones.

This painting technique is not as complex as it may seem at first. The composition is selected and drawn on to the canvas and the light acrylic underpainting is then applied quickly and loosely. Giving this time to dry, the artist re-establishes the drawing with charcoal and fixes it with a spray fixative. The acrylic underpainting provides the middle value of the painting. Dark oil glazes are applied all over the charcoal drawing and the acrylic ground. Areas are then wiped back to expose the acrylic middle tone; the remaining glaze represents middle-tone darks and darkest darks. All that is left is to add minimal passages of opaque to represent the highlights. This demonstration of a mixed media painting technique can provide the artist with a fast, spontaneous approach to the subject.

Materials: Canvas size 20 in × 40 in (50 cm × 100 cm); brushes – Nos. 10 and 12 flat bristle, 1 in (25 mm) wide blender or household brush; conté crayon; charcoal; putty eraser; disposable palette; rags; 3 jars of water; atomizer for water; turpentine for cleaning oil brushes.

1 For this demonstration of mixed media (oil paint over acrylic), the model is placed in a bright source of light from the left which creates strong tonal values, the highlights being emphasized by the dark cover over the couch.

2 The artist uses a black conté crayon to block in the figure which fills the length of the long narrow canvas. The cushions break up the monotony of the fairly uniform couch, echoing the curves and softness of the body.

3 A delicate pastel underpainting is applied to lay a foundation for the oil overpainting. For the flesh, a flat ground mixed from raw sienna, cadmium red and titanium white is laid.

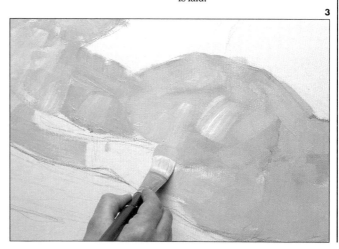

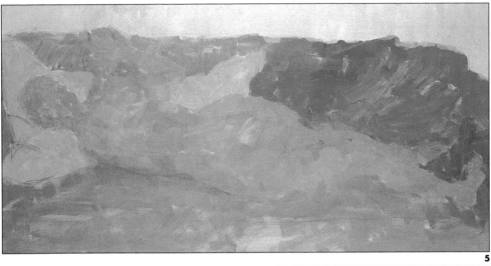

4 The underpainting is loosely completed in very pale colours – carmine, a small amount of ultramarine blue and white for the couch, raw sienna and titanium white for the background and the woman's hair, sap green and white for the large soft cushions.

5 The artist redraws the figures with charcoal over the acrylic underpainting. Charcoal is more sympathetic to the surface than conté crayon which skids over the acrylic paint without making marks. This is sealed with a spray fixative to prevent the small particles of charcoal from polluting the oil paint.

6 Using only transparent oil colours, the artist begins to add the overpainting. It is quite important for the artist using oil paints to know which colours are transparent and which opaque. A paperback book called *The Painter's Pocket Book of Methods and Materials* by Hilaire Hiler (pub. Faber) is a very useful guide. Failing that, you will find that many oil paint manufacturers state this information on the individual tubes.

7 The underpainting is painted rather dark: carmine red with a small amount of ultramarine blue for the rug over the couch, ultramarine blue and sap green for the cushions, all mixed with oil painting medium.

8 The underpainting is completed in no time at all, the transparent glazes being loosely applied. Raw sienna with the oil medium complete this stage with the overpainting of the hair and curtains in the background.

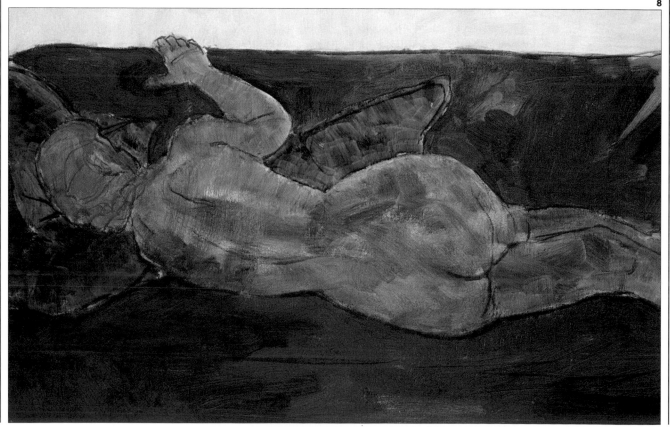

9 Using a 1 in (25 mm) blender brush, the artist goes all over the painting diffusing all of the brushstrokes and running all edges together.

10 With a clean soft rag (preferably cheesecloth), the dark glaze is lifted from the light side of the face, hair and cushions to establish a middle-tone value.

11 The rest of the body is treated in the same manner and now the couch to reveal the pastel underpainting.

12 The pattern of middle tones is completed and the artist can continue to develop the painting. If at this stage the artist feels that she has taken out too much of the glaze, it can easily be reapplied and the middle tone re-established.

13 Here the artist demonstrates correcting mistakes. The face of the figure was wiped out too much, giving the model the appearance of having a fat face, so the glaze is painted back in.

14 Stronger darks are needed in places. Here the artist has applied them with a brush and is smoothing the brushstrokes out in an isolated area with her finger. Fingers can be a helpful tool to the artist.

15 With a No. 10 flat bristle brush, the artist tidies up around the figure, sharpening the edges and strengthening dark areas that need it: for example, the shadow under the figure and the front of the couch (the foreground of the painting).

16 Opaque passages are added to the couch by mixing white with the transparent colour. Titanium white oil colour with a touch of burnt sienna is applied only into the area of the figure reserved for the very light. Do not destroy your middle-tone values that have been established by the acrylic ground.

17 Detail in the form of dark brushstrokes has been added to the folds in the curtains of the background. Here the artist applies a light opaque to the top of those folds.

18 This painting has a spontaneous quality about it. The charcoal drawing which can be identified through the paint film lends a sketchy, instinctive look to the work. Most of the surface is transparent, with the opaques held to an absolute minimum. The total effect is fluid and translucent.

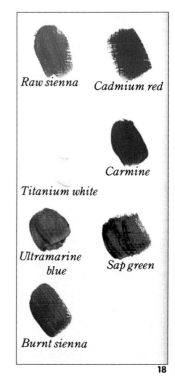

Raw sienna *Cadmium red*

Carmine

Titanium white

Ultramarine blue *Sap green*

Burnt sienna

17

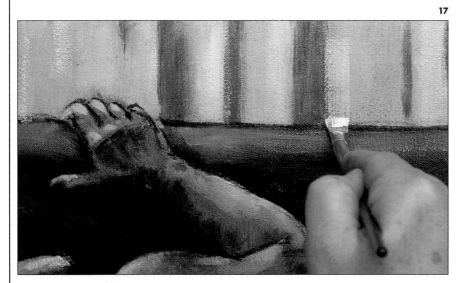

18

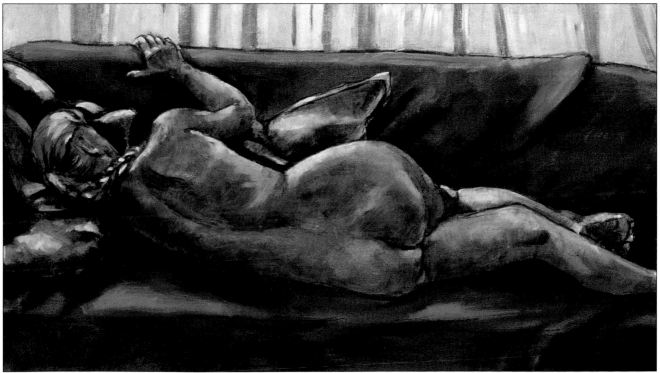

Cat

FURTHER TECHNIQUES

The subject of animals can be very challenging and needs practice, but it doesn't take too long before it becomes quite rewarding to the artist.

Initially it is best to use pencil or charcoal and to spend time sketching. If you have a pet of your own you have a ready-made model; if not, perhaps you can visit a friend with an animal you can draw. Failing that, you can always go to the zoo or out into the country. Whatever you choose to do, persevere as at first it will be frustrating. Animals move a lot; a sleeping cat seems to be aware that you are looking at it and will flick its tail, move a paw or its head, so patience is a necessity.

When you begin, concentrate on sleeping animals. Although they tend to move a bit, it is a lot easier than sketching an animal awake. Work quickly, look for definite lines and draw them. If the animal wakes up or moves while you are drawing, and they normally do, begin again. You will learn nothing by trying to complete the drawing that you have started. When you have more experience, then you can perhaps finish the picture from memory. Careful observation and sensitively drawn lines filling a page of your sketchbook will have taught you a lot more. Block out the drawing in simple shapes: the upside down triangle of a hen, the egg shape of a bird, the squareness of a cow; and carefully develop the drawing from this. In this drawing, the whole cat can be encompassed in an oval, its head a circle within that oval, its ears and nose triangles and its tail a long cylinder. The artist

sketched out these basic shapes before she began to build up the values with cross-hatching. Remember that animals are like humans, no two look exactly alike; some look fierce or mean whereas others look soft or quiet. Animals show their moods in other expressive ways too, different to humans, a cat's pupils will be little more than slit when the animal is content, large and round when afraid. Many animals use their ears to express feelings, also tails and hair along their backs.

Acrylic was used in this drawing, like permanent ink on a brush. Ultramarine blue and burnt sienna were mixed together in a little pot with water to the right degree of fluidity, enough made to execute the whole drawing. When the cross-hatching was finished and dry a few colour washes were added to complete the picture.

1 Animals are a demanding subject for the artist, twitching and fidgeting even when asleep. Studying their features and movements by using a sketchbook is a great asset to the painter. Here, the artist's tabby female cat, George, poses sheepishly on the kitchen counter.

Materials: Light green Ingres board 14 in × 21 in (35 cm × 52.5 cm); brushes – Nos. 2, 4 and 20 watercolour; 2B pencil; putty eraser; disposable palette; rags or paper towel; water atomizer; small pot; 3 jars water.

2 Using a piece of pale green Ingres mounting board as a support, the artist very lightly sketches an outline with a 2B pencil. Over this she adds to and darkens the drawing with a very watery mixture of ultramarine blue and burnt sienna – these two colours being the basis of the complete drawing. The brush used is a No. 4 sable watercolour with a fine point.

3 Using the grey thinned paint, the artist develops the cat's face, paying special attention to the eyes as they are the most predominant feature in the whole face.

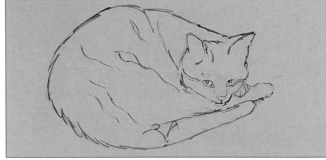

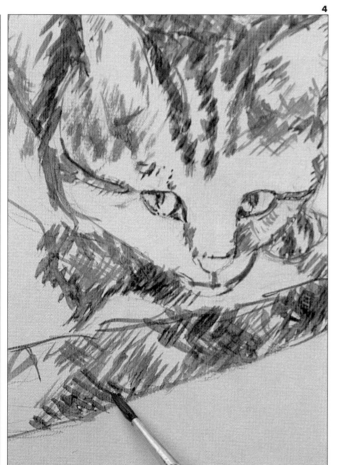

4 Working on the tail, the artist builds up the layers with cross-hatching strokes. Making a pot of the paint mixture, very much like ink, enables the artist to proceed at a rapid rate.

5 The whole of the outline of the cat is filled with the cross-hatching technique, the artist being aware of the undulating lights and darks of the tabby's fur.

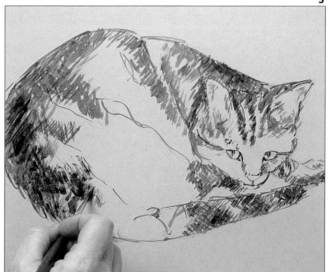

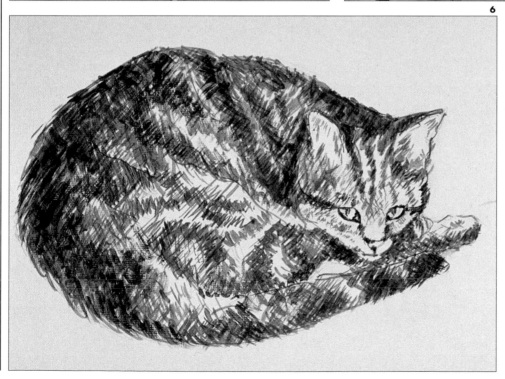

6 The cross-hatching process is completed, the artist has built up the area on the cat's back to the left of the support more than any other part. In this section the cat is actually black.

7

7 This detail gives the student a closer look at the cross-hatching technique employed. A gingery colour wash is mixed with raw sienna and burnt sienna and applied to the face with No. 20 synthetic watercolour brush.

8 The artist continues to apply this wash in the appropriate places. There is no worry of disturbing the drawing as acrylic paint is permanent.

8

9 To strengthen the darker areas and to add to the blackness, a wash of ultramarine blue is applied over parts of the head, back and tail.

10 Carmine is mixed with a little raw sienna and watered down to produce a soft pink for the insides of the ears and the tip of the nose.

9

10

11 For the highlights in the eyes, the artist uses a No. 2 sable watercolour brush and pure titanium white. Other white areas are added around the eyes, nose and mouth.

12 A No. 1 synthetic rigger brush is used with fluid white paint for the whiskers. The brush is pulled quickly in fine lines. Tiny hairs are applied in the same way to the ears.

13 To complete the delicate drawing, the artist mixes ultramarine blue and burnt sienna with a little cadmium red. With this and a No. 20 watercolour brush, she adds a shadow. This anchors the cat to the ground as previously it appeared to be floating in a vacant space.

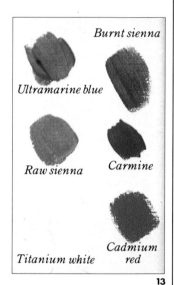

Ultramarine blue

Burnt sienna

Raw sienna

Carmine

Titanium white

Cadmium red

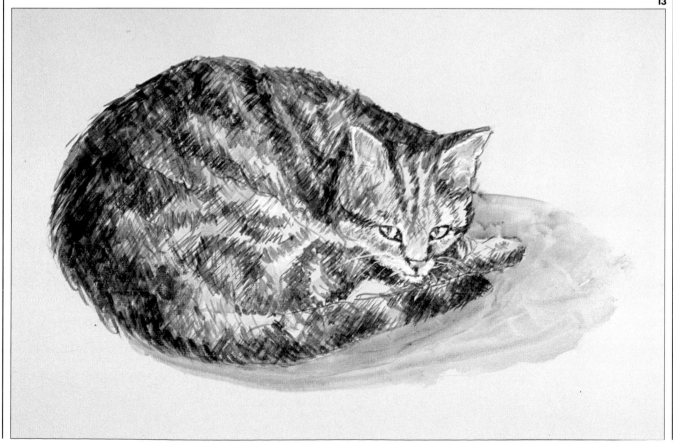

The Woodman's Garden

FURTHER TECHNIQUES

The subject of this painting could be found in most gardens. This demonstration shows that any subject matter, however simple and ordinary, when put together with imagination can make an appealing painting.

When setting up a still-life subject be careful not to make it appear contrived. The objects should look as natural as possible. Use a sketchbook and draw the subject from different angles before you begin to develop the composition on to your canvas. If you are not happy with the arrangement, rearrange it; do not begin the painting until you have arrived at the right solution to the problem – design of the composition.

In this instance, these objects were brought into the studio and displayed on a table, so the background had to be fabricated from the artist's imagination and memory bank. When you begin to paint, it is virtually impossible to draw from the memory as you will have little visual knowledge in store. The exercise of memory drawing is one way to develop this; that is, look at an object – still life, tree, house, person, whatever – and spend two minutes observing. After this time, turn away and try to remember and draw the object. Another way to develop your visual knowledge is to sketch, anywhere, anytime, anything and often.

To aid in the placing of tonal values in your still life, a light shining from a definite direction, usually from the right or the left, will make the light areas brighter and the darks stronger.

Thus, the final painting of this book exploits many of the techniques that we have learned in previous chapters – scumbling, stabbing on the paint, flicking the brush, using a sponge with unmixed colours, stippling and glazing and, in addition, the artist demonstrates the use of the palette/painting knife.

2

2 The artist spends some time pre-planning the composition and deciding what format she should use. To do this, she makes several rough thumbnail sketches. It is better to have some idea of the composition before working on the support as it cuts down on the confusion of many wrong lines.

1

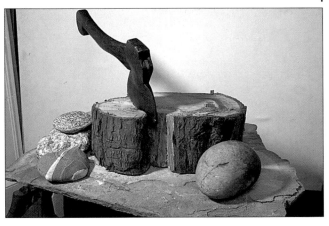

3

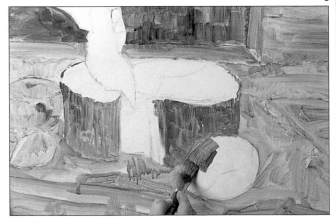

Materials: Canvas board 20 in × 28 in (70 cm × 70 cm); brushes – Nos. 10 and 12 flat bristle, No. 4 flat synthetic; sketchbook; 2B pencil; eraser; charcoal; spray fixative; disposable palette; 3 jars water; water atomizer; rags or paper towels; 2 palette/painting knives; piece of sponge.

1 A selection of textured objects, all relating, is set up in the artist's studio to demonstrate in a painting how acrylic can be manipulated to produce many textures. A bright light is directed on to the objects to produce a strong tonal value.

3 The drawing is established on to a canvas board support with a piece of willow charcoal. When satisfied with the outline, the artist flicks off any excess charcoal dust with a soft rag and then fixes the drawing with a concentrated spray fixative. The background of hedge and shed is added to the studio still life to add interest and to give the illusion of the objects being outdoors in a natural setting. Working from the top of the painting to the bottom, the

artist lays in thin washes of local colour pertaining to each individual object or area. Using a large brush, No. 12 bristle, a wash of sap green and ultramarine blue are used for the shed and bark of the log. The stones are painted with various mixes of ultramarine blue, burnt sienna and carmine: likewise the axe head. The handle is painted in burnt sienna, and the grass sap green.

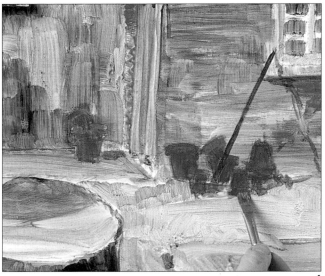

4 The artist, working very quickly and loosely, has applied local colour to the whole canvas. She now establishes the source of light by adding the darks.

5 An imaginary touch is added to the painting in the form of plant pots and a rake. This group of objects balances the composition and relates the background to the foreground.

6 The darkest tone of the hedge is painted in roughly in a cross-hatching brushstroke, allowing the paint to vary in thickness. This gives the impression of light coming through the thinner parts of the hedge.

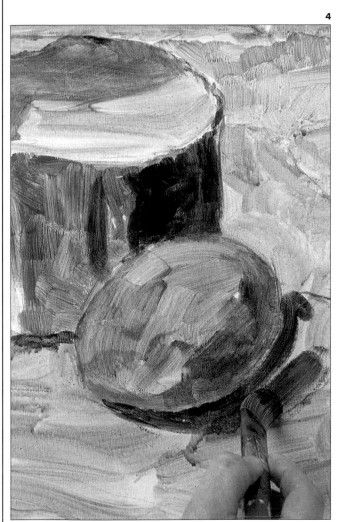

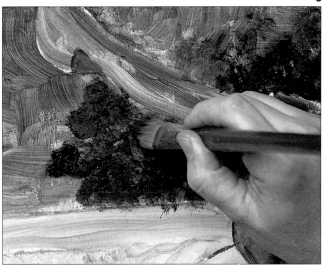

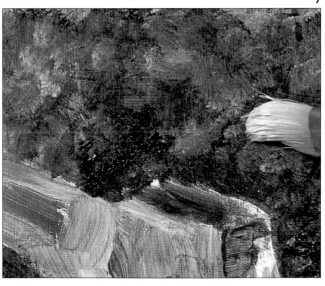

7 Light in the hedge is added by stabbing the brush on to the support, using a No. 12 bristle brush and sap green, lemon yellow, and titanium white.

8 With a mixture of raw sienna and ultramarine blue, the artist, using horizontal brushstrokes, scumbles paint on to the shed. Dark lines are then applied to give the appearance of overlapping boards and the doorway. The same mixture, ultramarine blue and burnt sienna, is used to darken the glass in the windows and the shadow of the rake handle.

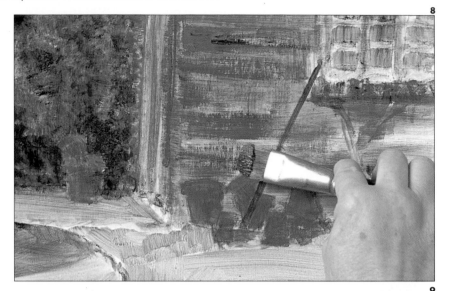

9 Painting the pots is the next step. Being careful not to overstate them, the artist uses a No. 4 flat synthetic brush and a mixture of cadmium red, burnt sienna and white. The rake is then painted in two tones, dark and light.

10 Small amounts of burnt sienna, lemon yellow, raw sienna, ultramarine blue and titanium white are put very closely together on the palette, but not mixed. The artist takes a damp sponge, dips it into the paints, picking up each colour individually and dabs it on the painting along the path. All of these colours together create the illusion of pebbles.

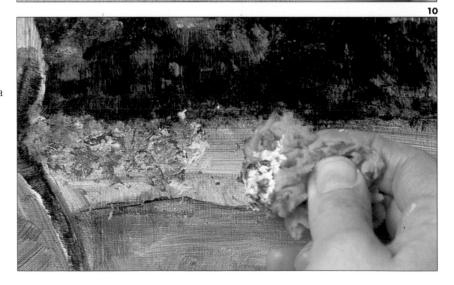

11 Trying to avoid uniformity, the artist paints the grass with a pulling down, bouncing motion of the brush. To do this she uses a No. 12 flat bristle brush containing sap green, lemon yellow, a little burnt sienna and titanium white not overmixed. It is important to keep dipping into the paint to vary the colour and texture.

12 The artist paints the three stones on the left. The top one is stippled with ultramarine blue and burnt sienna, after a mixture of raw sienna and white is sponged on. On to the middle stone a thin glaze of cadmium red and ultramarine blue is followed by darker detail and to the bottom stone the artist applies a mixture of ultramarine blue, burnt sienna and titanium white. The handle of the brush is used to scrape in light veins.

13 To paint the stone on the right, the artist uses a mixture of raw sienna and violet (ultramarine blue and carmine) with titanium white. For the dark side she uses ultramarine blue and burnt sienna. A thin glaze of white is scumbled over the lighter side and finally the cracks are added.

14 Texture is built up in the log; darks are applied first, then lighter greys are dragged down to create the bark. Darker paint is scumbled in a circular motion over the light colour of the 'slice' of wood to add the rings.

11

12

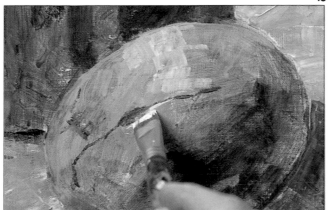

13

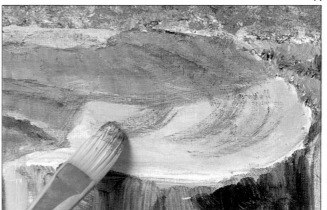

14

15 Both the axe handle and the head are simply painted in two tones: the light surface and the dark top edge. A little highlight is applied along parts of the edge of the axe with white.

16 Using a palette knife, the artist spreads the general colour of the stone slabs in the foreground which is raw sienna, titanium white and violet, the violet being made from ultramarine blue and cadmium red.

15

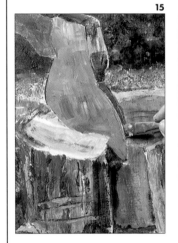

16

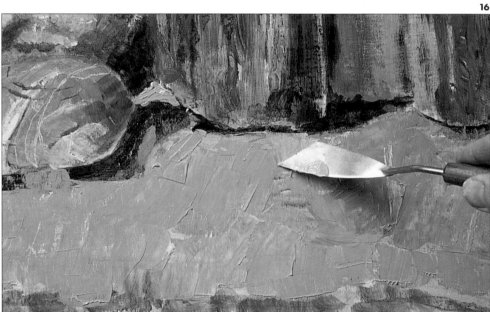

17

17 Still using the palette knife, the artist adds the shadows under the log and stones. Using a palette knife is not difficult; in fact, it could be compared to spreading butter on to bread. Using it in this area of the painting produces the right effect – layered sharp-edged rock-like slabs.

18

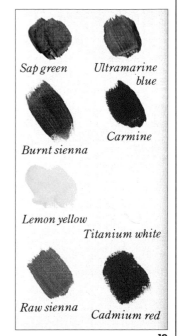

Sap green *Ultramarine blue*

Burnt sienna *Carmine*

Lemon yellow

Titanium white

Raw sienna *Cadmium red*

18 Finally, using the edge of a long pointed trowel-shaped palette knife the artist applies the cracks on and in between the stones.

19 Many textures and techniques have been used to develop this painting but still the composition holds together. This was achieved by the use of a limited palette, seven colours plus white, and the design of the work. The handle of the rake, the line of the grass in the crack on the right and the axe handle all carry the eye to the focal point, the axe head in the log. Here the eye is held by the brightest area in the painting, the yellow sliced log.

19

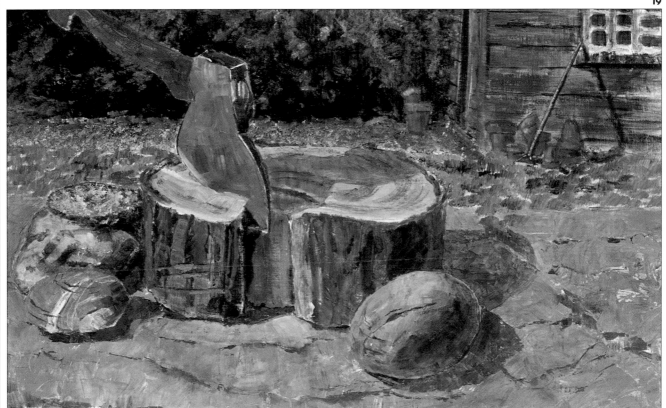

Index

Acknowledgements

The author would like to thank all those who have helped in the preparation of this book. Special thanks to Ian Sidaway for his work on some of the technique demonstrations and to Viv Arthur at Frisk Products for her advice and prompt supply of all materials from the Talens range.

Photography
Studio and Step by Step photography by
John Melville

Other Photographs

pp 10/11 Detail from *Guadalupe Island* by Frank Stella, The Tate Gallery, London
pp 14/15 The Tate Gallery, London
pp 16/17 No.s 1, 3, 4, 5 & 6 Business Art Galleries, London
pp 16 No. 2 The Tate Gallery, London

For Sports Editions
Art Direction: Richard Dewing and Mary Hamlyn
Design and layout: Sharon Smith, Jason Claisse and Adrian Waddington
Editor: Geraldine Christy
Finished Art: Rob Kellard
Origination: South Seas International Press Ltd., Hong Kong